IMAGES
of America

BASEBALL IN
WASHINGTON, D.C.

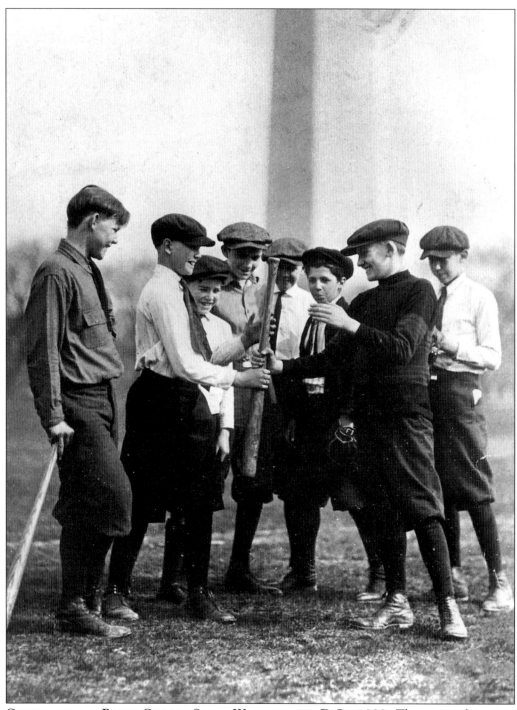

CONGRESSIONAL PAGES CHOOSE SIDES, WASHINGTON, D.C., 1922. The national pastime has always been popular in the nation's capital. The city not only enjoyed professional baseball for decades, but the game was popularly played by adults and youth alike. Here a group of congressional pages choose sides in front of the Washington Monument in 1922. (Baseball Hall of Fame Library.)

IMAGES
of America

BASEBALL IN
WASHINGTON, D.C.

Frank Ceresi and Mark Rucker,
with Carol McMains, researcher

ARCADIA

Published by Arcadia Publishing,
an imprint of Tempus Publishing, Inc.
2 Cumberland Street
Charleston, SC 29401

Printed in Great Britain.

Library of Congress Catalog Card Number: 2002100849

For all general information contact Arcadia Publishing at:
Telephone 843-853-2070
Fax 843-853-0044
E-Mail sales@arcadiapublishing.com

For customer service and orders:
Toll-Free 1-888-313-2665

Visit us on the internet at http://www.arcadiapublishing.com

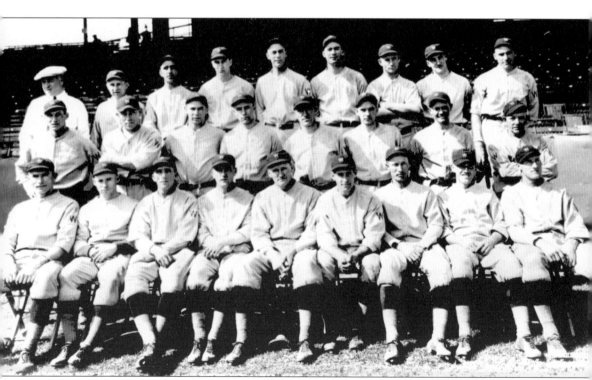

WASHINGTON BASEBALL TEAM, WORLD CHAMPIONS, 1924. After over 50 years of organized baseball, the city of Washington, D.C. finally celebrated a World's Championship when the Washington Senators won the dramatic 1924 World Series. (FC Associates.)

CONTENTS

ACKNOWLEDGMENTS

This book is not meant to be the definitive history of baseball in Washington. Rather, our hope is that through these illustrations we can all enjoy the spirit of our city's deep baseball tradition.

We do, however, owe a debt of gratitude to those who have written scholarly books. These titles should be considered required reading for anyone interested in baseball in the nation's capital: Morris A. Bealle's *The Washington Senators: The Story of an Incredible Fandom* (Columbia, 1947); Shirley Povich's *The Washington Senators* (G.P. Putnam's Sons, 1954); William B. Mead's and Paul Dickson's *Baseball: The Presidents' Game* (Farragut, 1993); Tom Deveaux's *The Washington Senators, 1901–1971* (McFarland & Company, 2001); James R. Hartley's *Washington's Expansion Senators, 1961–1971* (Corduroy Press, 1998); David Gough's *They've Stolen Our Team!* (D.L. Megbec, 1997); Henry W. Thomas's *Walter Johnson: Baseball's Big Train* (Phenom Press, 1995); Wilmer Fields's *My Life in the Negro Leagues* (Meckler, 1992); James C. Roberts's *Hardball on the Hill* (Triumph Books, 2001); John Holway's *The Complete Book of Baseball's Negro Leagues: The Other Half of Baseball History* (Hastings House, 2001).

We encourage interested persons to visit the Historical Society of Washington, D.C. to review the fantastic Edmund F. French Collection containing original manuscripts and materials on the Washington Nationals baseball team from 1859 through 1871.

We would like to thank in particular our friend Bill Loughman for his generosity in allowing us to use many of the images found in this book. Also, our sincere appreciation goes to Laura Daniels of Arcadia Publishing for her guidance and enthusiasm during this entire project. Finally, to our children, Dan and Nicole Ceresi, Brady McMains, and Caitlin Rucker, keep the spirit alive!

PHOTO LEGEND
T.G. = Transcendental Graphics, Mark Rucker, president
B. Loughman = Bill Loughman Private Collection
FC Associates = Museum Consultants and Sports Appraisers

INTRODUCTION

When a group of government clerks organized the Washington Nationals in the late 1850s just prior to the Civil War, little did they know that they would start a tradition in the capital city that can still be felt today. Baseball, called the summer game, or as American poet Walt Whitman aptly stated, "America's Game," reflects man's desire to play a simple yet complex contest requiring skill, strategy, and basic talent. Two teams would be organized in groups of nine and they would play one another in the great outdoors with only a bat, ball, and some scruffy clothing. If the players were lucky, each might even have a leather glove.

Washington, D.C. would see the game played professionally for well over a century. The city's fans, from everyday men and women to presidents and congressmen, would enjoy witnessing all of the greats of the game, from Babe Ruth and Shoeless Joe Jackson, who visited the city with their American League teams, to hometown heroes like the Senators' own Walter Johnson, arguably the greatest pitcher the game has ever seen.

Sadly and with little warning, D.C.'s professional baseball roots were ripped from the city some 30 years ago. Many of us are still waiting to enjoy the crack of a bat, to smell the popcorn, and to once again cheer on a major league hometown team. Others continue to play the game as it was intended . . . in a park, at a picnic, or even in the streets of the city. Once again, rumors persist that D.C. may, at long last, host a new team soon. We'll see! In the meantime, we hope that you enjoy the great memories that these images evoke and re-live, at least for a while, the glory of the past.

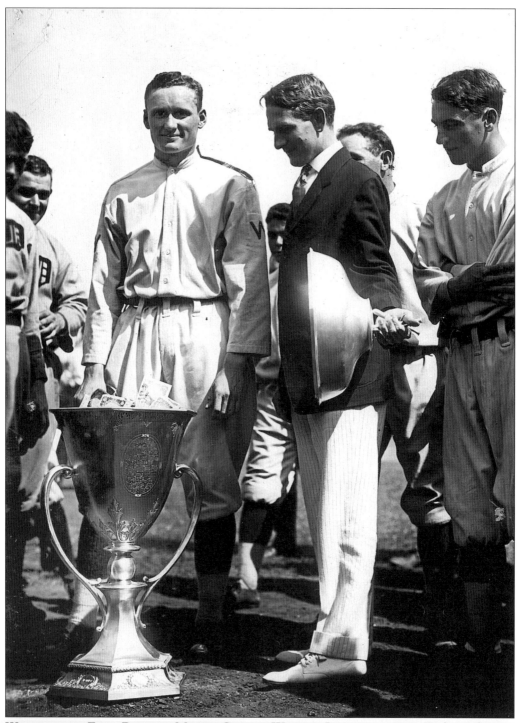

WASHINGTON FANS PRESENT MONEY CUP TO WALTER JOHNSON, 1913. Walter Johnson, after winning 36 games for the Washington Senators in 1913, is presented with a silver loving cup filled with money by the appreciative fans of the capital city. Presenting the cup to Johnson is D.C. Commissioner Oliver P. Newman. (B. Loughman.)

One

THE NATIONAL PASTIME IN THE NATION'S CAPITAL 1850s–1899

Baseball, dubbed "America's Game" by Walt Whitman over 150 years ago, has deep roots in Washington, D.C. In fact, the Washington Nationals, a team organized by a group of city government clerks looking to enjoy the outdoors, was founded in 1859, a scant 13 years after Alexander Cartwright codified the first rules of the game. By the end of the Civil War, ballplayers were so skilled at the sport that by 1866 they not only played just off the White House grounds with President Andrew Johnson rooting them on, but they also traveled south to the capital of the Confederacy itself, Richmond, Virginia, and north to Albany, New York, where they beat some of the top ballplayers in the country.

A year later, in 1867, the Washington Nationals spread the baseball gospel by traveling westward as far as Missouri. Spalding's Baseball Guide rightly called the tour "significant" for not only were the Nationals our nation's first touring professional baseball team, but the team was joined by a traveling sports journalist—the granddaddy of baseball writers and the inventor of the baseball box score, the famed Henry Chadwick. The team's exploits as reported by Chadwick (they only lost one game during the entire tour) were duly noted in the Washington Star and carried by other city newspapers throughout the east and midwest.

Within three short years, Washington resident and another recognized giant of the game, Nicholas H. Young, formed a rival team of ballplayers within the city limits. That team was called the Washington Olympics. Nick Young was later credited with organizing the National League of Professional Ballplayers, the very same major league that exists to this day! Within short order, D.C. baseball teams like the Capitals, Empires, Interiors, Unions, and Jeffersons sprung up throughout the city and its suburbs.

By the end of the 1870s and into the 1880s, inter-city rivalries flourished while the Nationals and Olympics played teams from all over the northeast, consistently drawing "kranks"—fanatics, or, as they became popularly known, fans. By the end of the century, Washington, D.C.-based teams were part of the short-lived Union and American Association Leagues and, for a brief period of time, the Nationals even joined Nick Young's own National League.

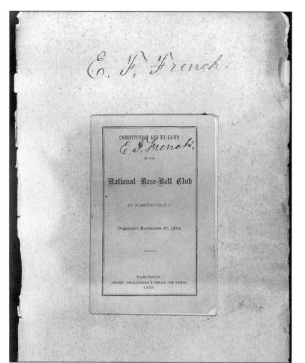

NATIONAL BASE-BALL CLUB CONSTITUTION AND BY-LAWS, 1859. Edmund F. French, a clerk in the Treasury Department, compiled the organizational charter of the Washington National Base-Ball Club. That team of government clerks was amongst the earliest organized ball clubs in the United States. The Nationals played in a field on Capitol Hill located about a mile from the United States Capitol. (Historical Society of Washington, D.C.)

EARLY BASEBALL TICKET STUBS AND INVITATIONS. The ticket stubs and invitations shown here are from the Washington Nationals and other baseball teams who played in the city in the mid-19th century. (Historical Society of Washington, D.C.)

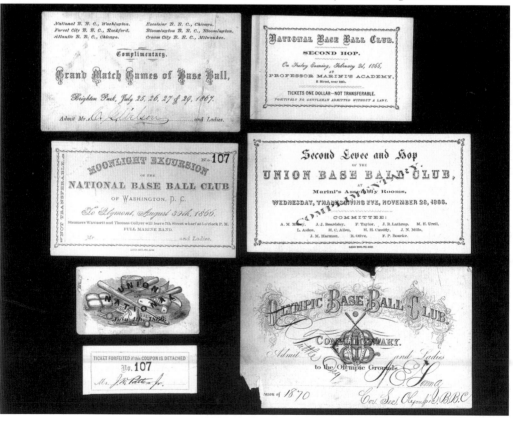

GEORGE WRIGHT, C. 1867. George Wright, a giant of 19th-century baseball, along with his brother Harry, was a member of the touring 1867 Washington Nationals. He is said to have hit six home runs for Washington in a game against the Indianapolis Westerns in Indiana during the tour. George was a member of the Cincinnati Red Stockings, the first professional salaried team in 1869, and was elected to the Baseball Hall of Fame in 1937. He is also known for starting Wright & Ditson, a very early sporting goods company. (T.G.)

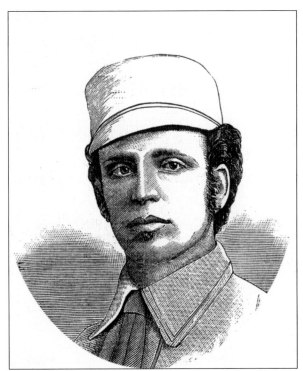

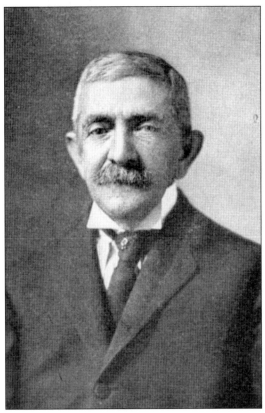

BASEBALL PIONEER NICHOLAS H. YOUNG. Nick Young learned the game of baseball as a soldier during the Civil War. Afterwards, he not only played on the field with the Washington Nationals but also organized the Washington Olympics ball club, formed a league of baseball players that still exists today as the National League, and even ran a school for umpires in downtown Washington, D.C. (T.G.)

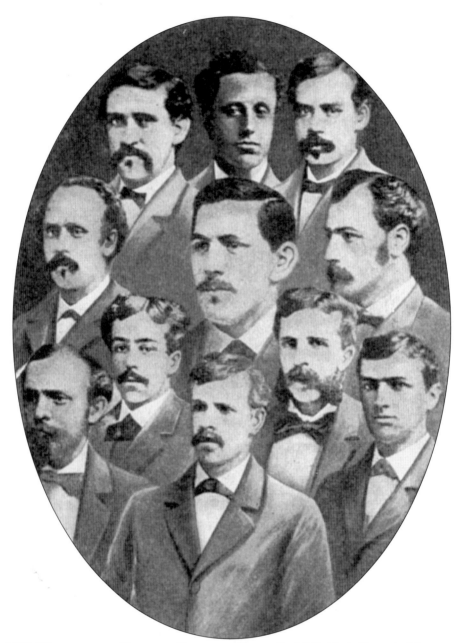

THE 1871 WASHINGTON OLYMPICS BASEBALL CLUB. By 1871, Nick Young's Olympics were challenging the Nationals supremacy as Washington, D.C.'s top ball club. The Olympics boasted several of the nation's top players including pitcher Asa Brainard, who two years earlier played on the Cincinnati Red Stockings. Also on the Olympics team was H.W. Berthrong, an outfielder who toured with the Washington Nationals in 1867. Pictured from left to right are (front row) H.F. Borroughs, D.L. Allison, and J.W. Glenn; (second row) D.W. Force and Asa Brainard; (third row) F.A. Waterman, C.J. Sweasy, and E. Mills; (back row) A.J. Leonard, G.W. Hall, and H.W. Berthrong. (T.G.)

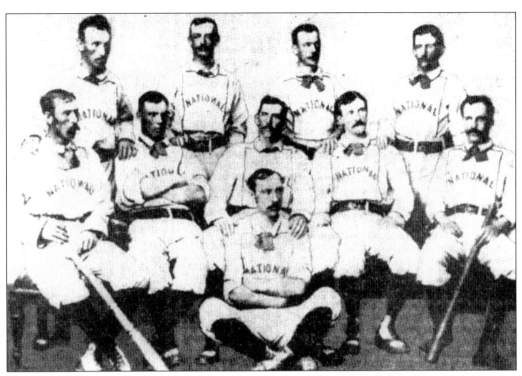

THE 1879 WASHINGTON NATIONALS BASEBALL CLUB. In 1879 the Washington Nationals were again credited by *Spalding's Baseball Guide* as being the premier Washington-based ball club. Johnny Hollingshead, the team's manager and second baseman (seated on floor), posted a .380 batting average that year and was rated second amongst the nation's batters. (T.G.)

PAUL HINES OF THE NATIONALS, C. 1886. Paul Hines was a fan favorite for the two years that he played for the Washington Nationals in the mid-1880s. The *Washington Star* rhapsodized about his "wonderful and brilliant running-catches." He was also a great hitter, leading all Washington hitters with a .312 average in 1886 and .371 a year later. (T.G., *Washington Star*.)

CONNIE MACK, OLD JUDGE CIGARETTE CARD POSE, C. 1888. Before he became the dignified manager and owner of the Philadelphia Athletics for several decades in the 20th century, a young and energetic Cornelius McGillicuddy—known popularly as Connie Mack—caught for the Washington Nationals from 1886 through 1890. While in Washington, Mack was amongst the earliest catchers to play just behind the plate instead of catching a pitched ball on the bounce. (T.G.)

SWAMPOODLE GROUNDS, WASHINGTON, D.C., C. 1888. This rare photograph shows the Washington Nationals playing the Chicago White Stockings at the old Swampoodle Grounds (where part of Washington's Union Station presently sits). The thin fellow behind the plate is said to be Connie Mack. The player hurling the ball is Hank O'Day, Washington's premier pitcher in the late 1880s. (T.G.)

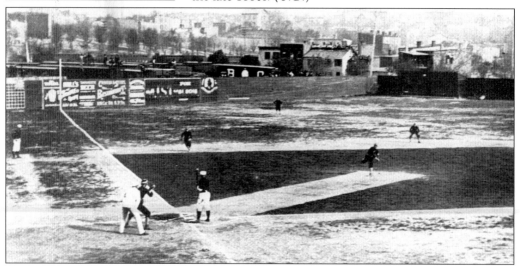

"GRASSHOPPER" JIM WHITNEY, OLD JUDGE CIGARETTE CARD POSE, C. 1888. Although Grasshopper Jim Whitney could hit and play first base, he was known primarily as a terrific pitcher. During the two years that he played for the Washington Nationals in 1887 and 1888, he won over 40 games. (T.G.)

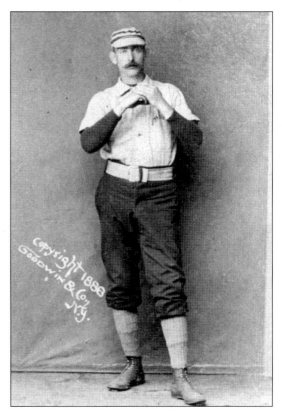

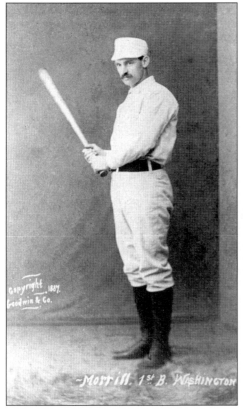

"HONEST JOHN" MORRILL, OLD JUDGE CIGARETTE CARD POSE, C. 1889. Honest John spent most of his distinguished 15-year career playing for the Boston Beaneaters. However, in 1889 he not only played first, second, and third base for the Washington Nationals, but he even pitched a game as well! (T.G.)

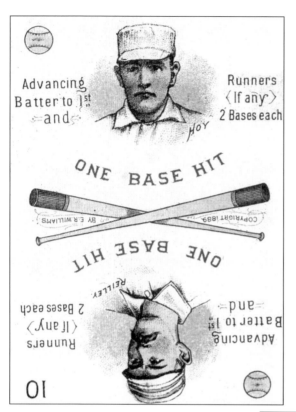

WILLIAM E. HOY, ONE BASE HIT GAME CARD, C. 1888. At the age of three, William Hoy contracted meningitis, lost his hearing, and therefore never spoke. However, as a young boy he developed a gift for the game of baseball and eventually had a brilliant 18-year career playing professionally. He played for two years with Washington in late 1880s, was a real fan favorite and, in fact, led all Washington hitters with a .274 average in 1888. That same year, in a game against Indianapolis, Hoy became only one of three major league outfielders ever to have three assisted outs—throwing from outfielder to catcher—in one game. Some say because he was hearing impaired, he was responsible for the use of hand signals by umpires. (T.G.)

"SURE SHOT" FRED DUNLAP, OLD JUDGE CIGARETTE CARD POSE, C. 1888. Fred Dunlap's nickname, Sure Shot, reflected his stature as the premier second baseman in all of baseball during the 1880s. After a stellar 12-year career for various teams, Sure Shot ended his career as a Washington National in 1891. The distinguished baseball historian Albert Spink in 1910 flatly stated that Dunlap was the best second baseman he ever saw. (T.G.)

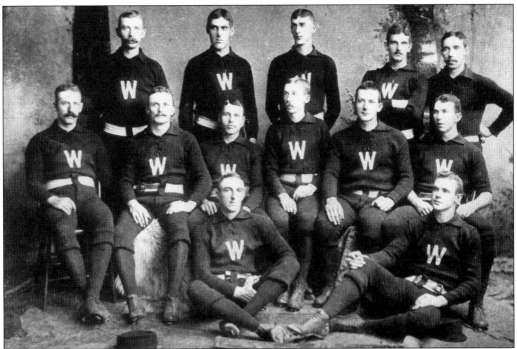

WASHINGTON'S ATLANTIC ASSOCIATION TEAM, 1890. The 1890 baseball season started out quite well for the Washington Nationals, who were part of the newly formed Atlantic Association. During the preseason games, they defeated all comers including the Baltimore Orioles and the Cuban Giants, a powerhouse of African-American ballplayers. Spirits were high early in the season when the team won 14 of their first 17 games. However, after losing 13 of the next 16 games, by July the season soured, fans stayed away from the ballpark in droves, and management was not able to meet the players' payroll. That was the death knell for Washington's Atlantic Association franchise. (T.G.)

"TEXAS" BUCK FREEMAN, C. 1891. Even though the Atlantic Association folded at the end of the previous year, professional baseball remained in the capital city but in a newly minted league. Texas Buck Freeman pitched for the 1891 Washington Nationals while that team was part of the short-lived American Association League. When this league folded at the year's end, Buck left professional ball and returned to his home in Texas. However, eight years later, he came back to play for Washington in 1899 when they had joined the National League. (T.G.)

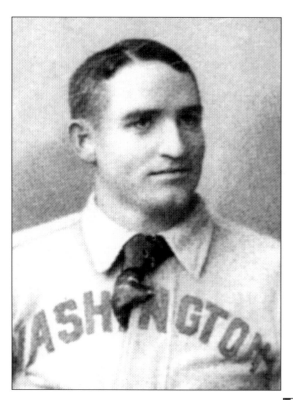

WILLIAM "SCRAPPY BILL" JOYCE, MAYO CUT PLUG TOBACCO CARD, 1894. For three years during the mid-1890s, Scrappy Bill Joyce was the Washington Nationals premier power hitter. He batted .355 in 1894, .312 in 1895, and .313 in 1896 for the new National League team. Because of his good looks, Joyce was popular with the ladies. The usually rough-hewn crowds at the ballpark took on a more genteel tone when Scrappy Bill played. (T.G.)

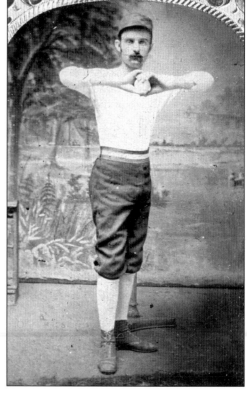

PITCHER GUS WEYHING TINTYPE, C. 1898. From the mid-1880s until 1910, Gus Weyhing won over 250 ball games for several professional baseball teams. He won 32 games but lost 48 for the woeful Nationals during the last two years of the 19th century. In 1899 the team lost almost twice as many games as they won. That same year *Reach Baseball Guide* began referring to the team "officially" as the "Senators," the moniker that would stick with the team until professional baseball left Washington, D.C. over 70 years later. (T.G.)

Two

THE SENATORS' GLORY YEARS AND THE BIG TRAIN 1900–1930

During the last eight years of the 19th century, the National League franchise in Washington, D.C. was unable to climb any higher than sixth place in the standings. Attendance at games dwindled as the fans' frustration with the team's losing ways mounted. In January of 1900, as the new century was born, the National League bought out the Washington franchise and promptly eliminated the team. Thus, as the new century began, the nation's capital was without a professional baseball club.

In 1901, however, a new league called the American League emerged and the city was awarded a franchise popularly called the Washington Senators. In 1903, the modern format of two major leagues—that still exists today—was born. Thus began seven decades of major league baseball in the nation's capital. The first 25 years would see a team that would lose a great deal, prompting the popular quote "first in war, first in peace, last in the American League," but the Senators would also set the city ablaze with excitement by capturing the World's Championship in 1924 and making a valiant run to repeat the next year.

The city would be blessed with a team owner, Clark Griffith, "the Old Fox," who most baseball historians today recognize as being one of the craftiest baseball men ever. He was a tough player in the mold of John J. McGraw and studied the game for years. The new century's early years would also mark a time that fans were treated to ballplayers with outstanding skill like future Hall of Famers Big Ed Delahanty, Sam Rice, Goose Goslin, and perhaps the greatest pitcher of all time, Walter Johnson.

How good of a pitcher was Johnson, the man whom sports writer Grantland Rice dubbed "The Big Train" because of his blazing fastball? Well, numbers don't lie even when you pitch for a team with mostly mediocre annual records. No other pitcher in the 20th century won so many games (he notched 416 victories) and Johnson led the American League in victories seven times and in strikeouts twelve times. In one season, 36 of his 37 starts were complete games! Simply put, Johnson's talent, honed through his years as a Washington Senator, places him at the very top of the list of all-time major league pitching greats.

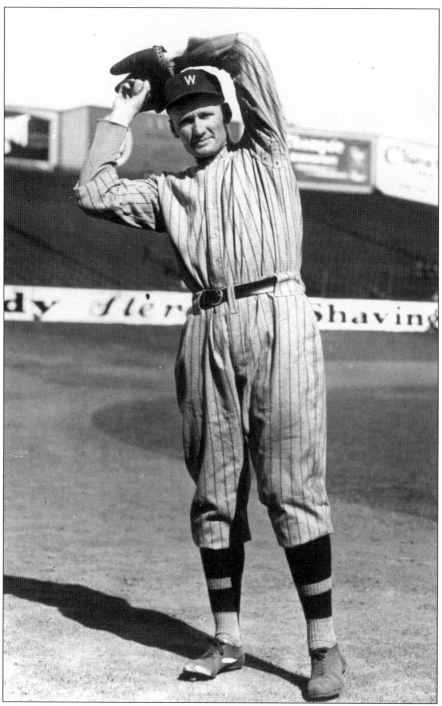

WALTER "THE BIG TRAIN" JOHNSON. Walter Johnson played his entire career with the Washington Senators. From 1907 through 1927, he won over 400 games for a team that was generally weak hitting. Johnson later managed the Senators for two years and was inducted into the Baseball Hall of Fame in 1936. *The Sporting News* and others voted the Big Train amongst the top athletes in the 20th century. (T.G.)

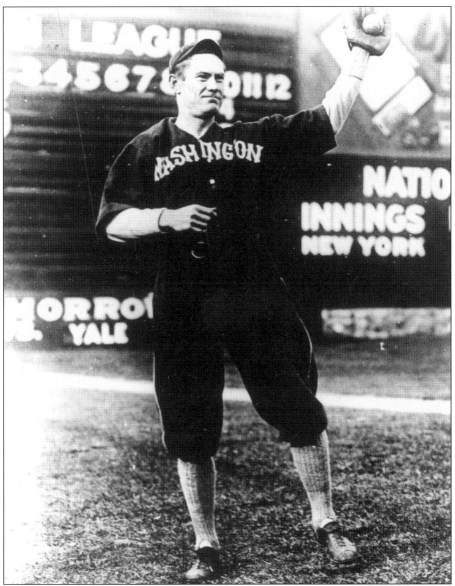

"BIG ED" DELAHANTY, 1902. Before there was Babe Ruth, fans everywhere celebrated baseball's first great slugger, Big Ed Delahanty. During his 16-year major league career, most of which he played in Philadelphia, Big Ed hit over .400 three times, went six for six in two separate games, once smacked ten straight hits, and even hit four home runs in a single game. He was without question Washington's first big catch for the new American League team. Delahanty played the entire 1902 season in Washington and led the majors with a .376 average. Sadly, the big catch would end up with a bizarre and mysterious ending. In 1903 he was hitting at an even .333 clip, but in July the apparently distressed ballplayer left the team while they were playing in Detroit and took a train to see his wife in New York City. He never made it, however, for he was thrown off the train in mid-trip near Niagara Falls for being drunk and disruptive. As he tried to make his way to safety near the deep waters, what occurred next is the mystery. Some say he got into a fight, and others say he slipped and fell. Either way, Big Ed disappeared into the raging waters and his body was found seven days later. (T.G.)

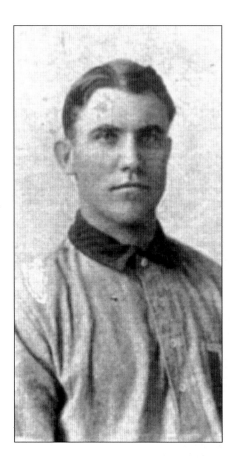

"SMILING AL" ORTH, C. 1902. One of the first players signed by the new Washington team, Smiling Al Orth eventually won 40 games for the Senators over a two-and-a-half-year period. All in all, the happy gentleman won over 200 games in the major leagues. (T.G.)

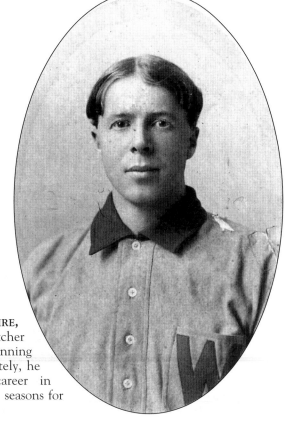

CASE PATTEN, PITCHER EXTRAORDINAIRE, C. 1905. Patten was Washington's best pitcher for the first decade of the 20th century, winning over 100 games as a Senator. Unfortunately, he got little run support during his career in Washington, as the team had long losing seasons for each of those same ten years. (T.G.)

D.C. City Baseball, 1905. Even
though Washington fans were frustrated
by the Senators' losing ways, the game
flourished in the streets of the capital
city. There were numerous amateur ball
clubs representing church, youth, and
community groups throughout the city.
Here, the boys of the Columbia Stars
proudly pose after winning 26 games in a
row to take the 1904 D.C. championship
for 16-year-olds. They are identified by
number as follows: (1) Woodworth,
(2) Paine, (3) M. Moore, (4) Goodnough,
(5) Parsons, (6) B. Moore, (7) Randolph,
(8) Porter, and (9) F. Crane.
(FC Associates.)

**The Megaphone Man of
Washington, c. 1908.** From 1901 to
1928, E. Lawrence Phillips, Washington
baseball's Megaphone Man, roamed the
ballpark stands with a megaphone
announcing each game's lineup. Thus,
while entertaining the Washington fans,
Mr. Phillips became the nation's first
modern-day public announcer. (T.G.)

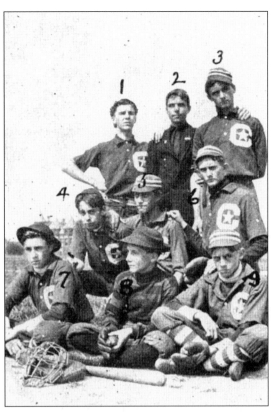

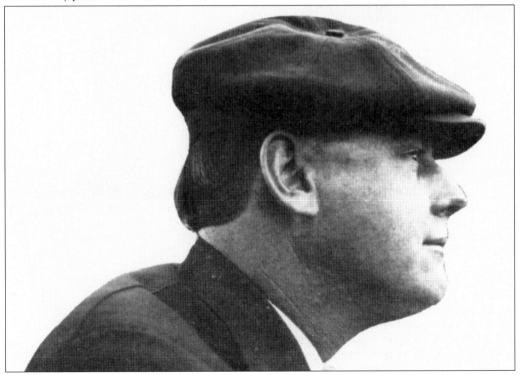

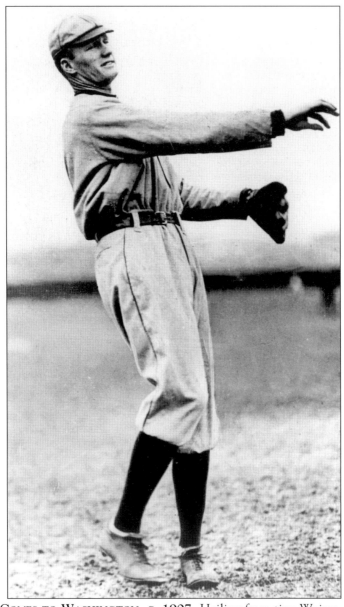

MR. JOHNSON COMES TO WASHINGTON, C. 1907. Hailing from tiny Weiser, Idaho, 19-year-old Walter Johnson was signed by the lackluster Washington Senators to shore up their pitching woes. After all, the American League team had losing records every year since 1901. Initial expectations of the young man were mixed. On the one hand, team officials were overjoyed when they received news that Walter had pitched 75 scoreless innings in the Idaho State League without giving up a run. On the other hand, one of their more cynical scouts said that trying to land the big right-hander would simply become a "wild goose chase." However, fate blessed the city when Walter came to D.C. By the time he finished his spectacular playing career, he had notched 416 victories with 110 of them by shutout, struck out over 3,500 batters, and led his team to a world championship. The modest gentleman became the idol of millions nationwide. "The Big Train," the greatest right-handed pitcher of them all, was elected to the Baseball Hall of Fame in 1936. (T.G.)

WASHINGTON'S BATTERY MATES, 1910. In 1910, *The Sporting News* featured the great pitching battery of the Senators, "the Big Train," and his catcher Gabby Street. Street would forever be known for two baseball firsts in Washington lore: he was the Big Train's first major league catcher, and, in 1908, he caught a baseball dropped from the Washington Monument. The team won only 66 games in 1910—Johnson himself winning a league-leading 25 of them. (T.G.)

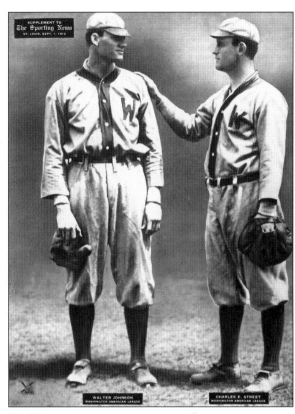

WALTER JOHNSON GAME CARD. Fans from the capital city and elsewhere collected tobacco and other cards featuring the budding star. This game card is one such collectible that shows the young pitcher Walter Johnson of the Washington Senators. (T.G.)

OPENING DAY, 1911. This rare photo shows the Washington Ballpark on opening day in 1911. Within a short time, the ballpark went through extensive renovations after a fire, and by 1920 it was to be officially named Griffith Stadium after Senators owner Clark Griffith. The stadium, with some alterations, housed major league baseball in Washington, D.C. for a half-century. (T.G.)

CLARK GRIFFITH, C. 1912. Clark Griffith, born in Missouri in 1869, won 20 games a year as a major league pitcher for six straight seasons during the 1890s for the Chicago Cubs. He ended up winning 237 games during his stellar playing career. His mark on the game of baseball, however, was not as a player on the diamond but as the owner of the Washington Senators. Although he played briefly for the team, he owned the franchise from 1912 until his death in 1955. "The Old Fox" was smart, crafty, and tough, and he knew the game well. Within short order, he attempted to surround his prize pitcher, Walter Johnson, with talented players like Chick Gandil. (FC Associates.)

CHICK GANDIL, C. 1912. Chick Gandil is known today primarily for his role as being a charter member of the Chicago Black Sox. Gandil, with seven others including Shoeless Joe Jackson, would be banned from major league baseball for life for throwing the 1919 World Series. In Washington, however, Gandil was hot property as the new owner, Clark Griffith, brought the hard-hitting youngster from Montreal to provide hitting to go along with Walter Johnson's pitching. (T.G.)

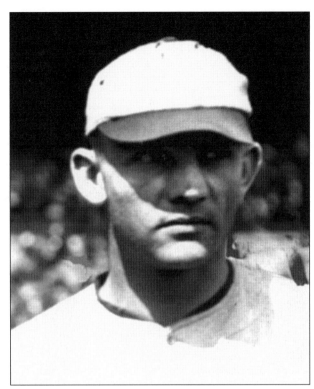

CUBAN JACK CALVO, C. 1913. Jacinto Calvo y Gonzalez, born in Cuba but known as Jack Calvo in the United States, played for the Washington Senators in 1913 and again in 1920. Throughout his years as owner, Clark Griffith would sign many young Cuban ballplayers to play for the Senators. Calvo was the earliest. (T.G.)

CLYDE "DEERFOOT" MILAN, C. 1909. Within three weeks of Walter Johnson's arrival in Washington, Clyde Milan was signed to play for the Senators for a little over $1,000. That was quite a deal for the team because Deerfoot was an outstanding outfielder who played 16 solid years for the club. He was also Walter Johnson's best friend and roommate for many years. (T.G.)

THE PERFECT PITCHER, C. 1915. By 1912, Clark Griffith had started turning things around for his team when they came in second place in the American League by winning 91 games. The Senators would win over 80 games each year until 1916. This photo shows Walter Johnson in his best pitching form in 1915, the year he led the American League with 27 victories. (T.G.)

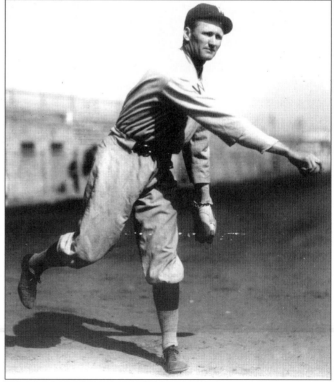

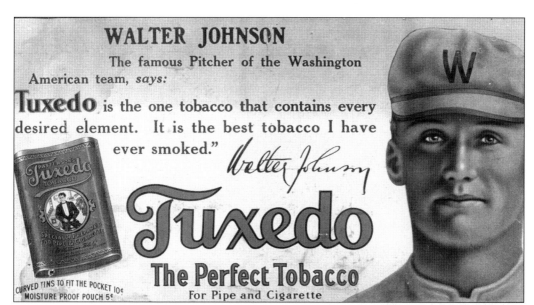

WALTER JOHNSON

The famous Pitcher of the Washington American team, *says:*

Tuxedo is the one tobacco that contains every desired element. It is the best tobacco I have ever smoked."

Walter Johnson

Tuxedo

The Perfect Tobacco

CURVED TINS TO FIT THE POCKET 10¢
MOISTURE PROOF POUCH 5¢

For Pipe and Cigarette

WALTER JOHNSON'S MARKETING APPEAL. By the mid teens, the Big Train was so popular that he was one of the first athletes in the United States with great marketing appeal. Walter Johnson appeared on the cover of *Baseball Magazine* in 1915 (right) and on a trolley car sign for Tuxedo Tobacco (above). (T.G.)

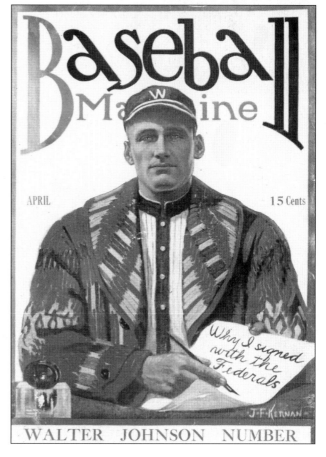

Baseball Magazine

APRIL 15 Cents

Why I signed with the Federals

J.F.KERNAN

WALTER JOHNSON NUMBER

EDDIE "KID" FOSTER, C. 1915.
Eddie Kid Foster played for the
Senators from 1912 through
1919. Though only a .264 hitter,
Clark Griffith once said Foster
was "the best hit and run man
that I or any other man owned."
Foster was a player solidly in the
mold that Griffith loved—a
defensive whiz, smart, and a good
contact hitter. Also, he played
every inning of every game for five
straight seasons. (T.G.)

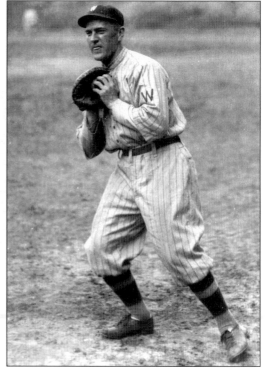

JOE JUDGE, C. 1918. Joe Judge and Sam
Rice would be teammates for a single team,
the Washington Senators, for 18 years. This
major league record would stand until the
mid-1990s. Judge ended up with a lifetime
batting average of .298 and hit well over
.300 during D.C. baseball's key years in the
mid-1920s. (T.G.)

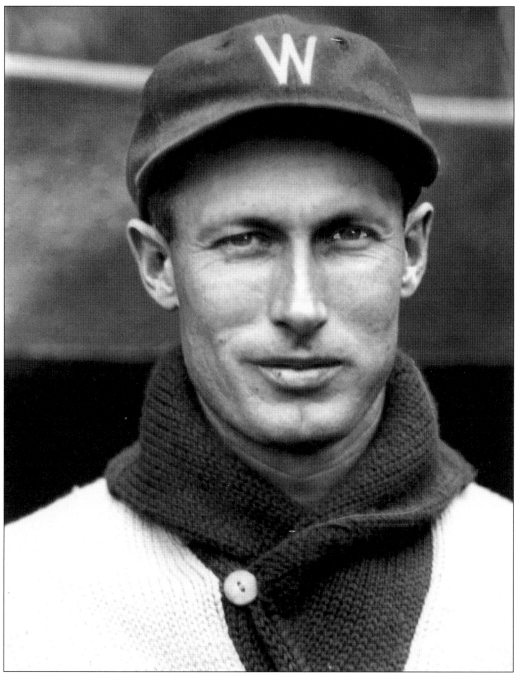

SAM RICE, C. 1925. Edgar Charles Rice enlisted in the Navy in 1913 and ended up pitching for the baseball team while aboard the *U.S.S. Hampshire*. In late 1915, he signed with the Washington Senators. Clark Griffith was not impressed with Rice's pitching ability, so he was switched to play in the outfield by the end of 1916. This proved to be a smart move as Rice played in over 2,000 games with the Senators, ended up with a lifetime batting average of .322, and was eventually inducted into the Baseball Hall of Fame. He was a Washington mainstay during the 1924 and 1925 World Series. (T.G.)

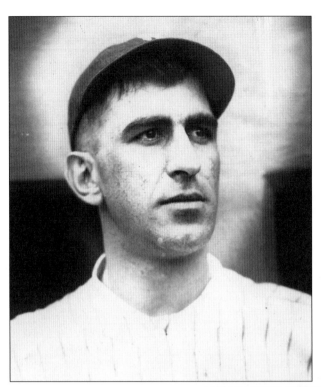

ROGER PECKINPAUGH, C. 1922.
By 1922, the Senators team was in need of a veteran shortstop to anchor the infield. Clark Griffith zeroed in on Roger Peckinpaugh, who had played shortstop for the New York Yankees for years. Peckinpaugh had the stability Griffith was looking for, and the crafty owner landed the prize shortstop in a complicated multi-team deal by giving up some cash to Red Sox owner Harry Frazee. Peckinpaugh was solid for the 1923, 1924, and 1925 seasons and played well during the 1924 World Series. Unfortunately, he committed several errors during the 1925 World Series that seemed to cost the team some key runs. (T.G.)

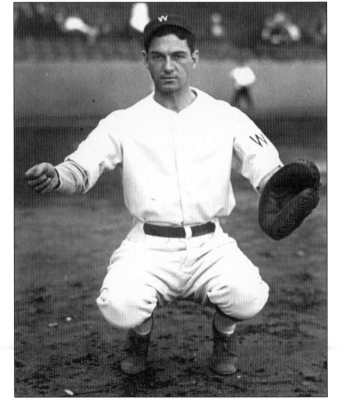

HEROLD "MUDDY" RUEL, C.
1923. Catcher Muddy Ruel played seven years with the Senators beginning in 1923. New manager Stanley Harris and owner Clark Griffith were thrilled to have the defensive stalwart, not only for his glove and bat but because he was tough and smart as well. Ruel was an attorney during the off-season and years later became assistant to Major League Baseball Commissioner Happy Chandler. (T.G.)

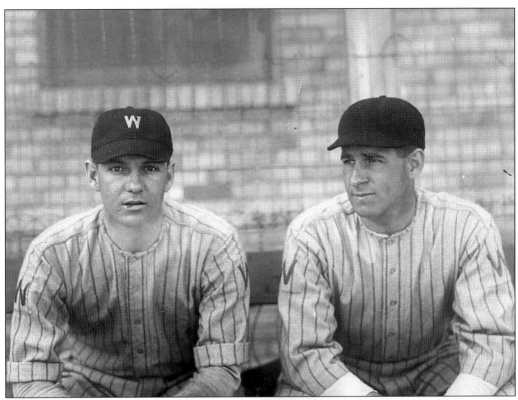

"MUDDY" RUEL AND NEW MANAGER STANLEY "BUCKY" HARRIS, C. 1924.
Bucky Harris started playing second base for the Senators in 1919. Clark Griffith took note of his heady defensive play, and, in an attempt to find a winning combination that would put the Senators over the top, the owner named Bucky player/manager for the team in early 1924. The gamble paid off as Harris led the team strategically from the dugout and played brilliantly at second base during the critical stretch drive that autumn as the Senators overcame the New York Yankees and, at long last, positioned themselves to play for the world championship. (B. Loughman.)

LEON ALLEN "GOOSE" GOSLIN, C. 1924.
Goose Goslin played with the Washington Senators during the 1924, 1925, and 1933 pennant-winning campaigns. Many argue that he was the best hitter ever to play for the Washington Senators. Goslin ended his career with a .316 lifetime batting average and was inducted into the Baseball Hall of Fame in 1968. (T.G.)

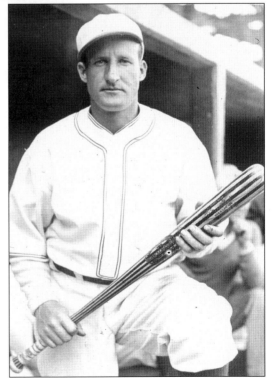

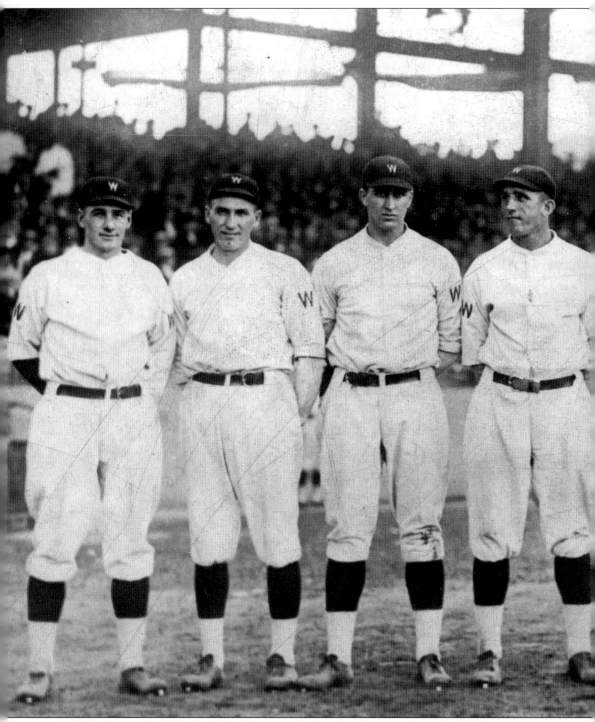

THE 1924 WORLD SERIES WASHINGTON SENATORS PITCHING STAFF. The entire city was thrilled when the Washington Senators won the American League pennant for the first time in their storied history. They were the underdogs set to face John J. McGraw's tough New York Giants National League ball club, but the Senators, largely on the strength of Walter Johnson,

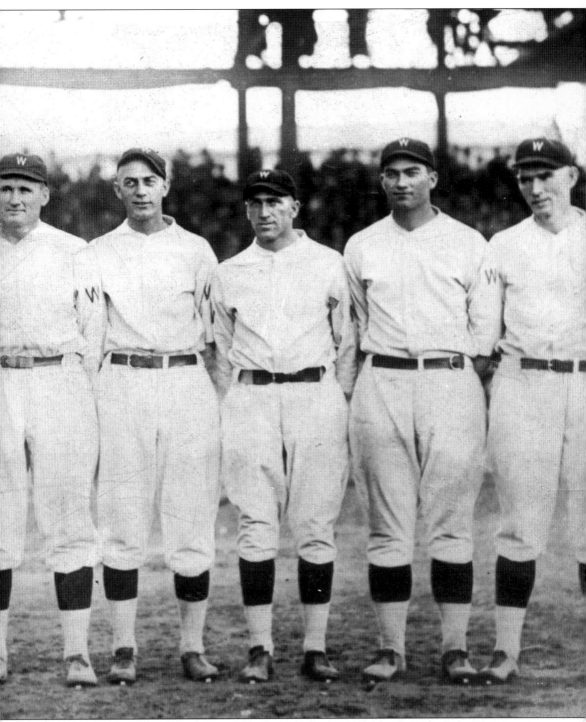

were clearly the fans' favorites not only in the nation's capital but throughout the country as well. This photo shows the pitching staff that would take on the Giants. Pictured from left to right are Paul Zahaiser, Byron Speece, Curley Ogden, Joe Martina, Walter Johnson, George Mogridge, Allen Russell, Fred Marberry, and Thom Zachary. (B. Loughman.)

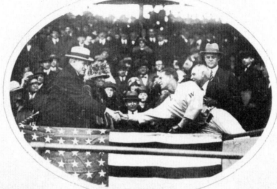

WASHINGTON BASE BALL CLUB

PENNANT WINNERS 1924

WORLD SERIES 1924 WASHINGTON vs. NEW YORK

THE 1924 WORLD SERIES PROGRAM. All of Washington, D.C. was excited in anticipation of the World Series opening game that would feature Walter Johnson pitching at Griffith Stadium. President Calvin Coolidge and manager Bucky Harris adorn the cover of the official scorecard that was sold at the stadium. (FC Associates.)

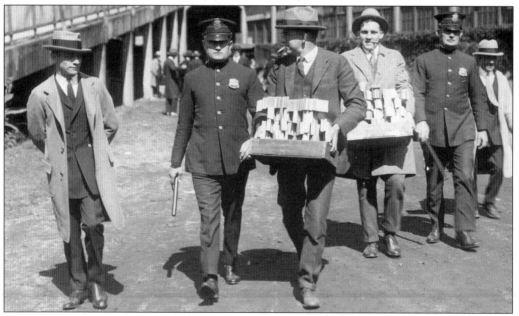

GRIFFITH STADIUM 1924 WORLD SERIES. Police guard the hottest tickets in town, those for the 1924 World Series game held at Griffith Stadium in downtown Washington, D.C. (T.G.)

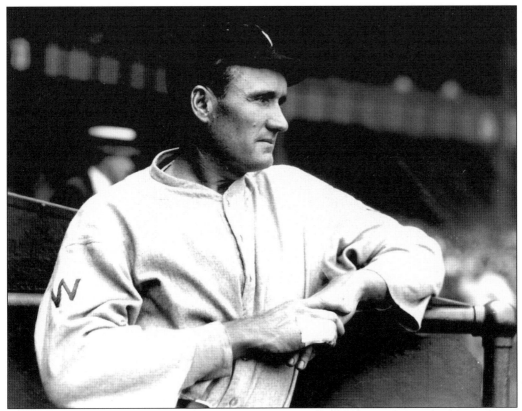

A PENSIVE WALTER JOHNSON. Like it was scripted for a movie, Walter Johnson, a mainstay for the Senators for almost 20 years, won the critical seventh game of that year's World Series in extra innings on October 10, 1924, before his hometown fans. This close-up shows Walter deep in thought, contemplating the task ahead. (T.G.)

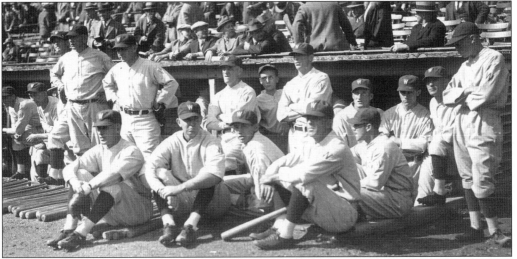

THE 1924 WORLD SERIES SENATORS DUGOUT. As Walter Johnson contemplated his pitching duties, his team's batters get ready to do battle with the pennant-winning New York Giants during the 1924 World Series. (B. Loughman.)

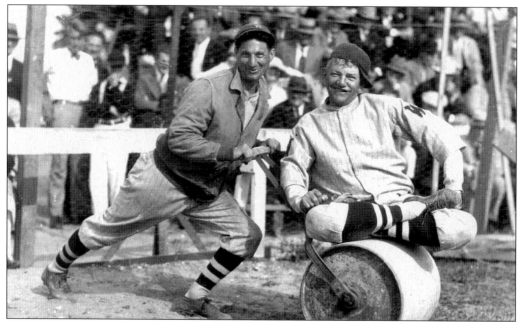

WASHINGTON CLOWNS AL SCHACHT AND NICK ALTROCK, 1924 WORLD SERIES. These are two happy men. Nick Altrock, right, was with the Washington baseball club first as a player and later as a coach and entertainer, suffering along with the Washington fans through many losing seasons. Al Schacht, left, initially signed to pitch for the Senators but found his true calling as the "Clown Prince of Baseball." He teamed up with Altrock, and the duo entertained countless fans for many years. Here they get ready to cheer for the home team, the Washington Senators, during the 1924 World Series. (T.G.)

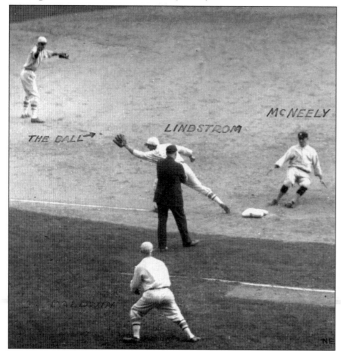

THE KEY PLAY, 1924 WORLD SERIES. This photograph shows the play that led to the Senators' first big win. A storm erupted at Griffith Stadium after journeyman Earl McNeely made the hit that allowed Muddy Ruel to win the 1924 World Series for Washington. First at last! (T.G.)

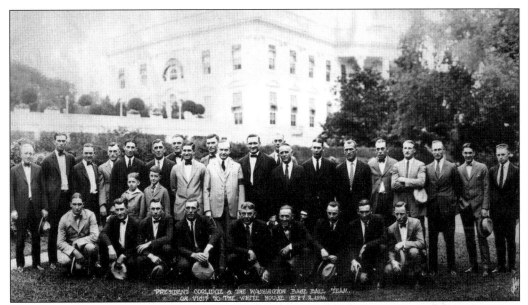

THE 1924 WORLD CHAMPION WASHINGTON SENATORS. After the thrilling Washington Senators World Series victory, President Calvin Coolidge hosted the hometown championship team at the White House. Here President Coolidge is surrounded by manager Bucky Harris and a beaming Walter Johnson. (T.G.)

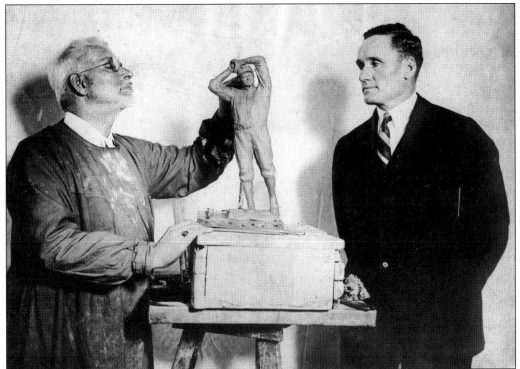

A LIVING LEGEND. By the time Walter Johnson came in as a relief pitcher to win the decisive seventh game of the 1924 World Series, he was a hero around the country. Sculptor U.S.J. Dunbar created the popular Walter Johnson statuette. (B. Loughman.)

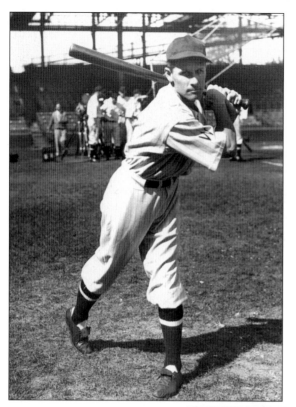

OSSIE BLUEGE HOLDING DOWN THE HOT CORNER, C. 1925. Ossie Bluege became a key addition when he was signed as a 20-year-old in 1921 to play for the Washington Senators. A peerless glove man at third base, Ossie played his entire 18-year career with the Senators. Not only did he play in the World Series for Washington in 1924, 1925, and 1933, but he eventually coached and directed the farm system for the team after his retirement as a player. (T.G.)

FREDERICK "FIRPO" MARBERRY, C. 1925. Like his good friend Ossie Bluege, Firpo Marberry played for the Senators during the 1924 and 1925 World Series. He was a tough Texas pitcher who loved to intimidate batters and once even challenged the entire New York Yankees dugout—including Babe Ruth himself—to settle their differences off the diamond and in the parking lot! It is said that there was dead silence in the Yankees dugout because even they didn't want to tangle with Firpo. (T.G.)

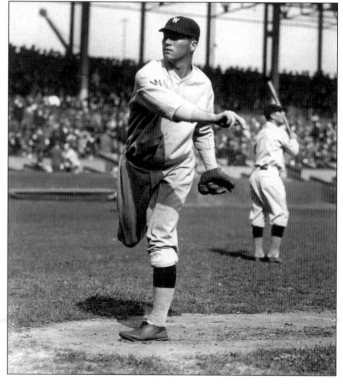

PITCHER STAN COVALESKIE, 1925. Born Stanislaus Kowalewskie to a family of coal miners, future Hall of Famer Stan Covaleskie was a work horse for the Cleveland Indians for nine straight years prior to being traded to Washington after the Senators' World Series victory in 1924. Thought to be through with a worn-out arm, Stan won 20 games for the defending champions in 1925, leading the American League in winning percentage for the year. He was largely responsible for the team winning their second consecutive American League pennant. Unfortunately, however, the great pitcher ran out of gas in October, lost two World Series games for his new team, and would never really dominate again. (T.G.)

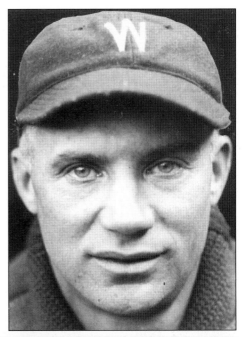

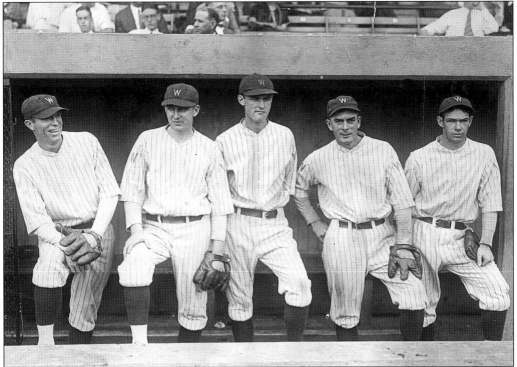

THE 1925 DRIVE FOR THE PENNANT. Stanley Harris, the young manager who took the Washington Senators to a world's championship the very first year he managed the team, added several young recruits in September to help the team in its successful pennant drive. Pictured from left to right are "Blue" Jeanes, Alec Ferguson, Al Smith, Bobby Veach, and Win Ballow. (B. Loughman.)

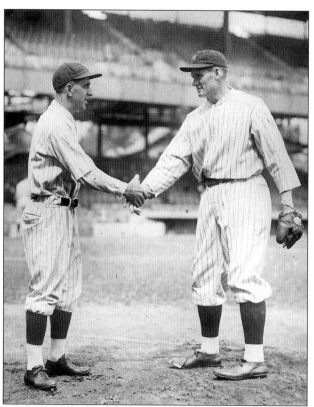

MEETING OF THE MVPs. After the defending World Champion Washington Senators won the pennant for the American League and were waiting to battle the Pittsburgh Pirates for the 1925 crown, Walter Johnson (who won the American League Most Valuable Player award in 1924) is seen congratulating teammate Roger Peckinpaugh (who won the American League Most Valuable Player award in 1925). (B. Loughman)

GRIFFITH STADIUM'S WORLD SERIES CROWD, 1925. Baseball fans in the capital city lined up early at Griffith Stadium to buy tickets for the 1925 World Series. They would be disappointed as Pittsburgh defeated Washington four games to three to snatch the crown from the Senators. (T.G.)

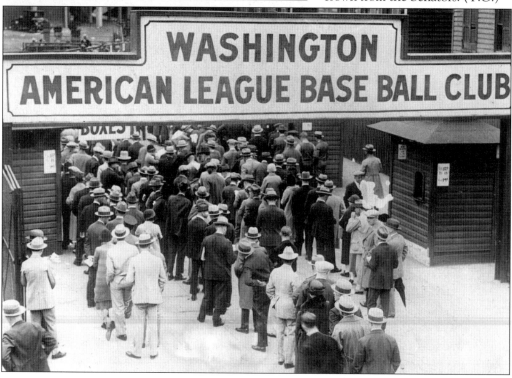

WALTER JOHNSON, FAMILY MAN, 1926. Although Walter Johnson and his teammates were disappointed by losing the World Series to the Pirates in 1925, he at last had time to relax with his family. Here a gloved Walter poses with his new daughter Barbara Joan one week after her birth. Viewing her new sister is young Carolyn. In 1995, Carolyn's son, Henry W. Thomas, wrote the definitive book on his grandfather entitled, *Walter Johnson: Baseball's Big Train.* That award-winning book is required reading for anyone interested in Walter and the Senators during their glory years. (B. Loughman.)

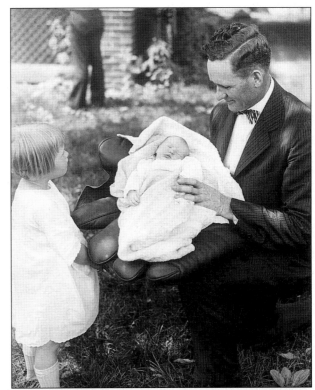

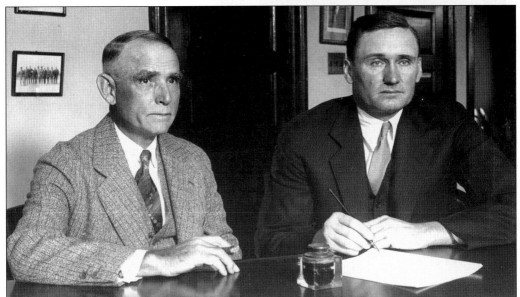

A NEW DAY, 1928. After breaking his leg in a freak accident during the 1927 preseason and winning only five games for the year, Walter Johnson retired as a player for the Washington Senators. Without the strength of his pitching arm, in fact, the wheels of the team began to unhinge and in 1928 the Senators had a losing record. Clark Griffith, looking for a change, released Bucky Harris and soon thereafter signed Walter Johnson on to manage the team. "The Big Train" would lead the team into the 1931 season. (B. Loughman.)

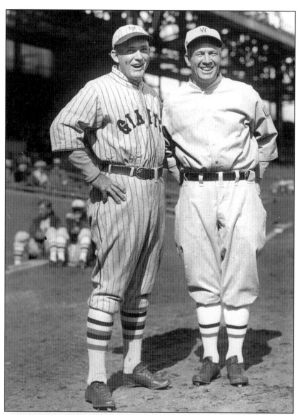

WASHINGTONIAN TRIS SPEAKER WITH ROGERS HORNSBY. During the same preseason that Walter Johnson broke his leg, the Senators signed 38-year-old Tris Speaker to play for them during the 1927 season. The great Hall of Famer had a solid year with the club while batting .327. Here he visits with his old friend, Rogers Hornsby, who was then playing with the New York Giants. (B. Loughman.)

THE BIG TRAIN AND BUCKY MEET AGAIN, 1929. Walter Johnson and Bucky Harris meet again at Griffith Stadium—this time as managers of opposing teams. Bucky's Detroit Tigers lost the first game of their series to the Big Train's Senators, 8 to 2. (B. Loughman.)

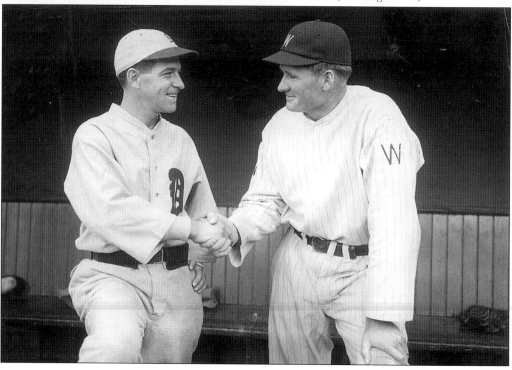

Three

THE GAME CONTINUES

THE 1930s

Baseball in Washington during the 1930s mirrored the highs and lows of life across the United States. It was a decade of contrasts. The nation suffered through the Great Depression, yet President Franklin Roosevelt and his "New Deal" administration took over the capital city and began to help the country climb out of economic chaos. Baseball in Washington also had its highs and lows. The Senators saw glory once again in 1933 when they captured the American League pennant and gained a third World Series appearance. However, the Senators lost the World's Championship and, as the decade wore on, the team began an erratic and slow decline.

The decade also saw old stars, including Sam Rice, Goose Goslin, and Walter Johnson (who managed the team after his playing years), slowly give way to a new crop of excellent ballplayers like player/manager Joe Cronin, Cecil Travis, Buddy Myer, Heinie Manush, and others. In the meantime, the old Senators stalwart and favorite of owner Clark Griffith, Bucky Harris would manage the team once again.

Even during the 1930s when fans saw their team play at times erratically, they were treated to some outstanding baseball. After all, the national pastime solidified its cultural hold on the country and the Senators, happily for those who could witness the greatest of the ballplayers, were in the dominant American League. It is in the "junior" circuit that the New York Yankees' Babe Ruth continued to hit gargantuan home runs for the first half of the decade while Lou Gehrig, his teammate and a gentleman on and off the field, ended the decade in 1939 with a consecutive games played streak of 2,130, a record of durability that would last until the end of the century.

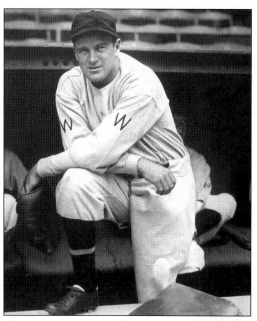

PLAYER/MANAGER JOE CRONIN, C. 1933.
Joe Cronin was probably the best all-around shortstop in the major leagues between 1928 and World War II. He played for the Senators during the first seven years of his career and managed the team in 1932 as well. Cronin would lead the Senators into the World Series once again. (T.G.)

BACK TO THE SERIES! JOE CRONIN AND "THE OLD FOX," 1933. Player/manager Joe Cronin is hoisted towards the sky and owner Clark Griffith beams as the Washington Senators celebrate winning the American League pennant in 1933. They would go on to play the New York Giants in the World Series. (B. Loughman.)

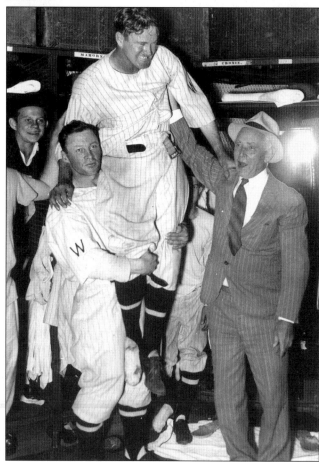

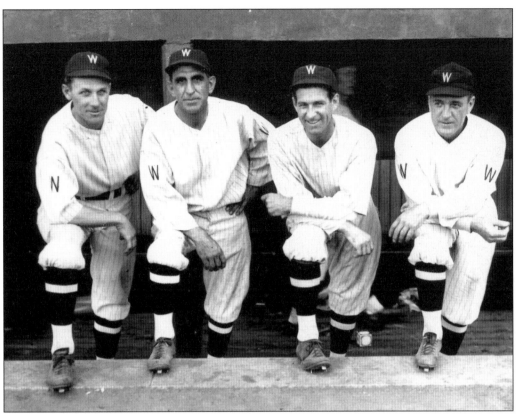

REUNION OF THE GREATS. In 1932, Washington fans were still treated to the presence of greats from the glory years of the 1924 and 1925 World Series teams. Above, the infielders from the 1924 World Championship team pose together in the dugout at Griffith Stadium. Pictured from left to right are Ossie Bluege, third baseman; Roger Peckinpaugh, shortstop; Bucky Harris, second baseman and team manager; and Joe Judge, first baseman. (T.G.)

"MUDDY" RUEL HONORED BY FORMER TEAMMATES, 1931. Although the Senators managed by Walter Johnson won over 90 games in 1931 and again in 1932, they only ended up in the middle of the pack in the American League standings. To keep the slowly declining gate as strong as possible, Clark Griffith often encouraged the team to hold ceremonies reminding the fans of the stars from the previous decade. Here attorney Muddy Ruel, now playing with the Boston Red Sox, is presented with an onyx desk clock for use in his off-season law office by old teammate and then Senators coach Joe Judge. (T.G.)

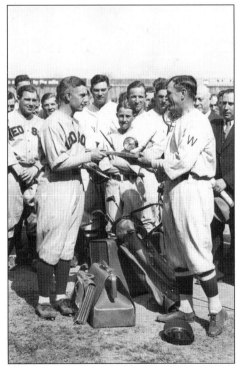

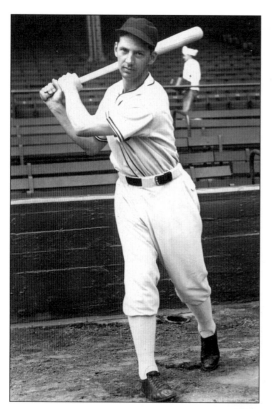

JOE KUHEL, C. 1932. Joe Kuhel played for the Washington Senators from 1930 through 1938 and then again during World War II. He was a solid hitter and eventually managed the team for two years in the late 1940s. Kuhel's best year was in 1933, with a club best .322 batting average when he helped the team take the American League pennant. (T.G.)

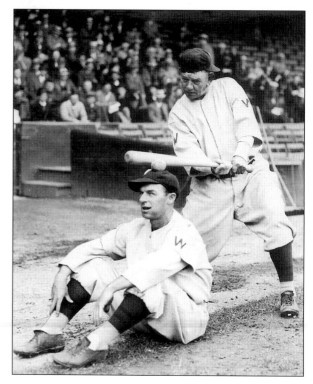

STILL CLOWNING AROUND, C. EARLY 1930S. Sometime Senator coach and full-time cutup Nick Altrock finds a new foil in teammate Fred Kerr. (B. Loughman.)

CECIL TRAVIS, C. 1933. During Cecil Travis's very first game in 1933 for the Senators, while subbing for an aging Ossie Bluege, he smashed five hits. For several years, some of which were pretty lean for the Senators, Cecil hit consistently and ended his career with a .314 lifetime batting average. Cecil played his entire career in Washington, D.C. (T.G.)

GLORY AGAIN! JOE CRONIN, 1933. In late 1932, four days before his 26th birthday, veteran shortstop Joe Cronin was named manager of the Washington Senators, replacing Washington institution Walter Johnson. In 1933, during Joe's very first year as a manager, he hit over .300 and deftly led his team to 99 victories and a berth in that year's World Series against the New York Giants. (T.G.)

MANAGERS MEET, 1933 WORLD SERIES. Here manager and shortstop Joe Cronin meets with Bill Terry, 34-year-old manager of the New York Giants, before the first game of the 1933 World Series. (B. Loughman.)

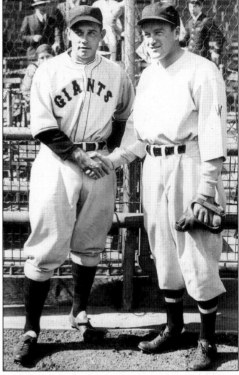

PITCHER MONTE WEAVER, 1933. Monte Weaver won 70 ballgames for the Senators during the 1930s. His best year was in 1932 when he notched 22 victories. Weaver started Game 4 in the 1933 World Series but lost the key contest to Hall of Fame great Carl Hubbell, 2 to 1 in extra innings. (T.G.)

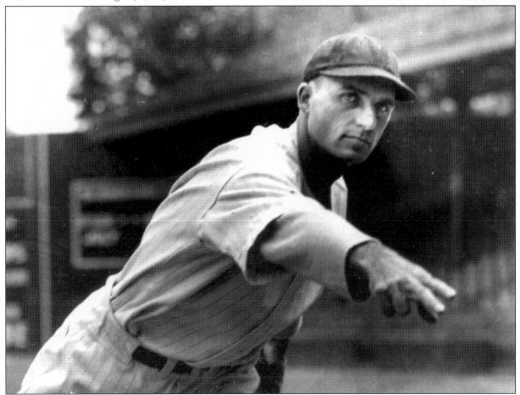

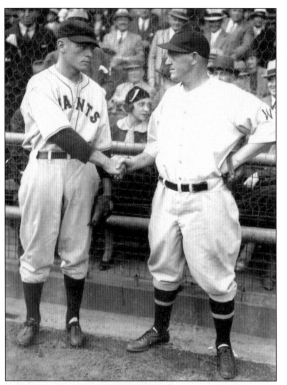

PITCHERS MEET, 1933 WORLD SERIES. This photo shows the starting pitchers for Game 2 of the 1933 World Series, Alvin Crowder for Washington and Hal Schumacher for New York. In the game, the Giants overcame a one-to-nothing deficit with six runs in the sixth inning to win the game. (B. Loughman.)

TEAMMATES FRED SCHULTE, GOOSE GOSLIN, AND HEINIE MANUSH, 1933 WORLD SERIES. Goose Goslin and fellow Washingtonians Fred "Fritz" Schulte and Heinie Manush get ready to take on the New York Giants during the last game of the 1933 World Series. Fritz would bat an even .333 for the series and Goose would hit a home run in Game 2. Heinie, who ended up batting a superior .330 during his illustrious Hall of Fame career, managed an anemic two hits during the series and, alas, the Senators would lose the championship to the New York Giants. (B. Loughman.)

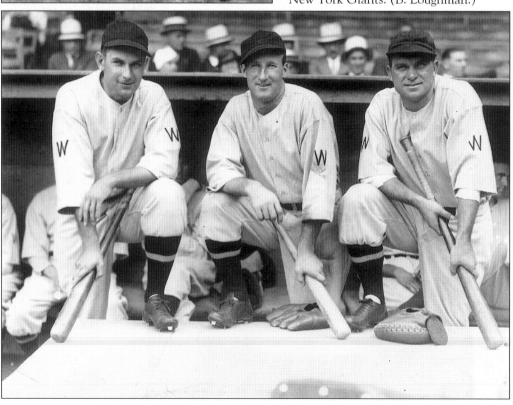

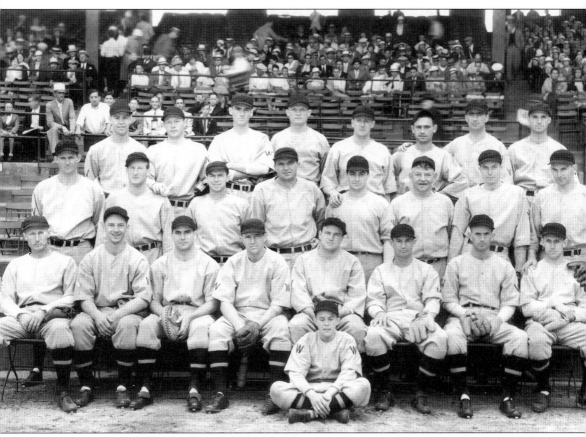

AMERICAN LEAGUE CHAMPIONS, 1933 WASHINGTON SENATORS. This team picture shows the last major league baseball championship team ever for the city of Washington, D.C. Although the Senators won the American League pennant, they were defeated in the World Series, four games to one, by the New York Giants. (B. Loughman.)

MORRIS "MOE" BERG, 1934. For 15 years, Moe Berg was an average baseball player with a very modest .243 lifetime batting average. He played for the Washington Senators during the 1932 and 1933 seasons and for over 30 games in 1934. His Washington teammates knew him more for his brains than his playing ability, as he was an alumnus of three universities, a lawyer, a mathematician, and a linguist who reportedly spoke 17 different languages! Perhaps even the Japanese couldn't quite figure out why, during 1934, Moe would travel to Japan as part of an exhibition baseball tour with Babe Ruth and other stars of the day. In fact, we now know that Moe was sent to Japan primarily to take photographs and gain intelligence for the United States government. Simply put, Moe was a spy for the United States! A few years later during World War II, he was assigned to the Office of Strategic Services (OSS), the forerunner of the CIA, and again gained valuable secret information for the United States. (T.G.)

HOUSE OF DAVID ADDITION, 1934. Even the mid-year addition of House of David star pitcher Allen Bunsen could not help the struggling Senators in 1934. A year after winning 99 games and making a World Series appearance, the team plummeted to a 66 and 88 season and ended up in sixth place in the American League. (B. Loughman.)

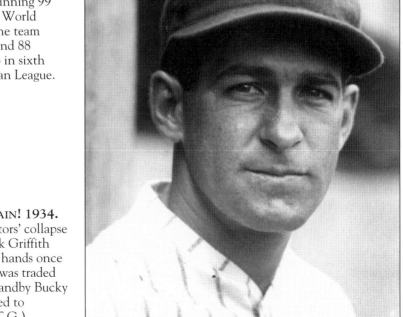

BUCKY HARRIS AGAIN! 1934. Because of the Senators' collapse in 1934, owner Clark Griffith changed managerial hands once again as Joe Cronin was traded to Boston and old standby Bucky Harris was again hired to manage the team. (T.G.)

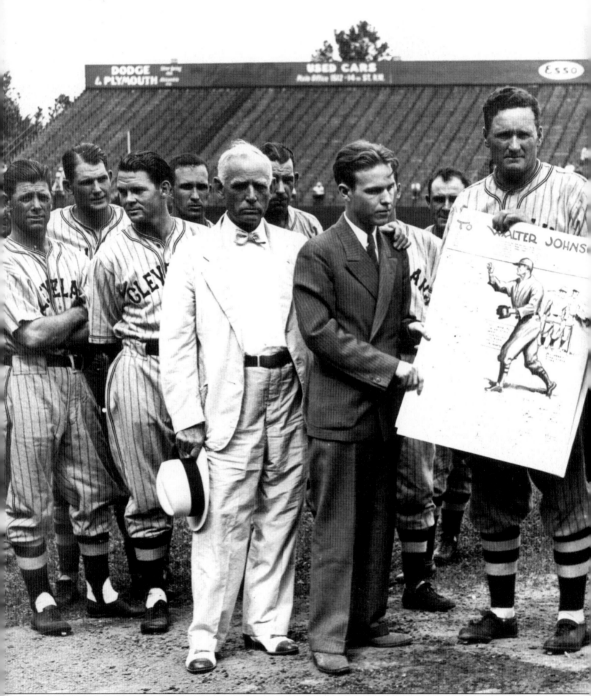

HONORING WALTER JOHNSON, 1935. The Big Train, now manager of the Cleveland Indians but still the idol of Washingtonians, was presented a huge scroll containing the names of thousands of D.C. fans at Griffith Stadium. Present from left to right are Senators owner Clark Griffith, president of the Washington Baseball Writers Association Richard McCann, Walter

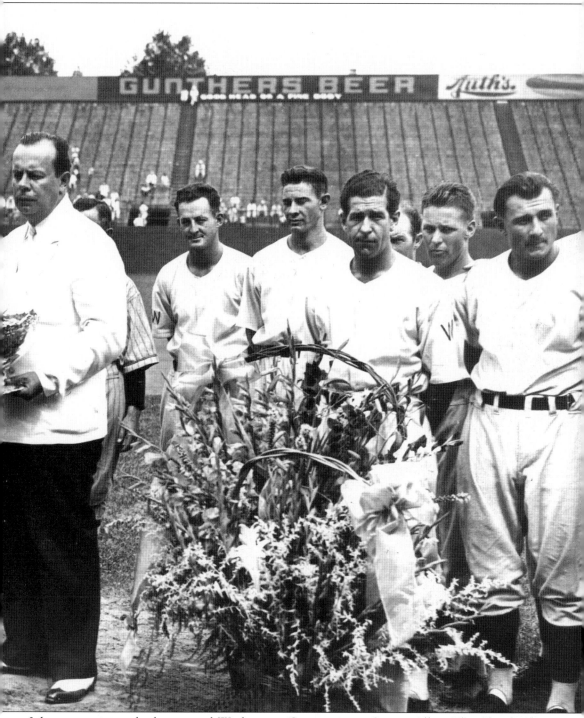

Johnson receiving the honor, and Washington Commissioner George Allen. The Cleveland and Washington teams, including Senators manager Bucky Harris (behind the flowers), flank the ceremony. (B. Loughman.)

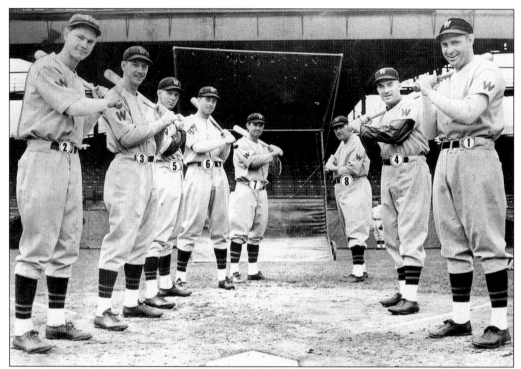

OPENING DAY, 1937. By the 1937 season, the Senators featured a fine array of batsmen. The Senators hitters pictured here, from left to right, are Buddy Lewis, Joe Kuhel, Jack Stone, Cecil Travis, Buddy Myer, Shanty Hogan, Al Simmons, and Ben Chapman. (B. Loughman.)

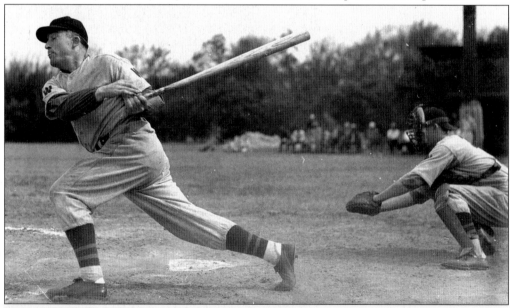

HALL OF FAMER AL SIMMONS, 1937. Fans hoped that the 1937 Senators lineup would be bolstered by future Hall of Famer Al Simmons, but even his solid .291 hitting couldn't jump start a team with great expectations. They ended up with a record of 73 and 80 and came in sixth place in the American League. (B. Loughman.)

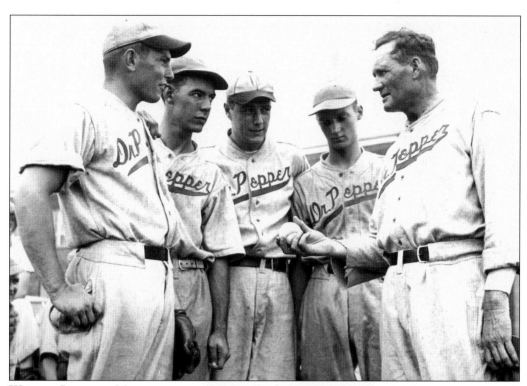

WALTER JOHNSON MANAGING THE DR. PEPPER BASEBALL TEAM, 1938. In 1937, Walter Johnson became a spokesman for the Dr. Pepper Company and during the year was asked to manage the company's baseball team. The team, which played the fastest semi-pro clubs in the Washington, D.C. area, included several stars from the 1937 National Football League champion Washington Redskins. (B. Loughman.)

PEPPERY SECOND BASEMAN BUDDY MYER. From 1929 through 1941, Buddy Myer was an exceptional second baseman for the Washington Senators. He played spectacularly in 1935 when he led the American League with a .349 batting average and thrilled fans for the rest of the 1930s with his heady defensive play. (T.G.)

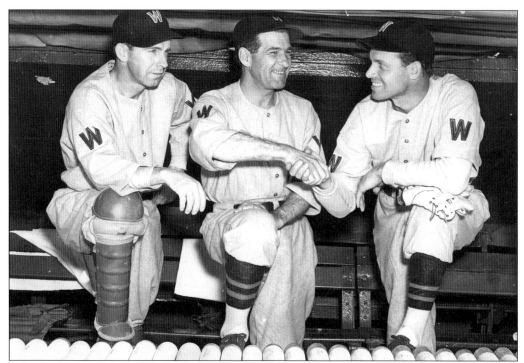

BUCKY HARRIS WITH THE FERRELL BROTHERS, 1938. Future Hall of Famer Richard Ferrell was a great catcher for the Washington Senators for eight years. In 1938, he caught for his brother and Washington Senators teammate, Wes. Wes Ferrell would win 13 games for the Senators that year but was traded to the New York Yankees by year's end. (B. Loughman.)

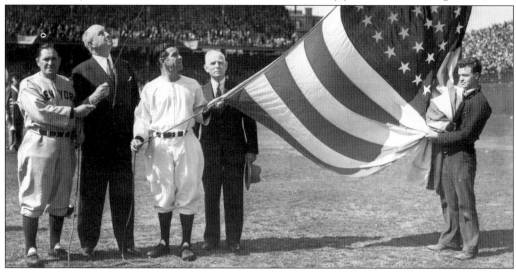

RAISING THE FLAG ON OPENING DAY, 1939. Although the Senators had a losing season in 1938, spirits were high before meeting the New York Yankees at Griffith Stadium for the opening game of the 1939 season. Pictured from left to right are Yankee manager Joe McCarthy, Postmaster General Jim Farley, Senators manager Bucky Harris (raising the flag), Senators owner Clark Griffith, and the Senators bat boy. The Senators would not only lose the game to the Yankees, but they would only win a dismal 65 games for the 1939 season. (T.G.)

60

Four

THE SENATORS, THE HOMESTEAD GRAYS, AND THE CLOUDS OF WAR THE 1940S

During the 1940s, life in Washington, D.C. was invigorating and exciting but ultimately harrowing. After all, on one hand the horrors of World War II occupied the federal government, dominated the country, and changed the look and feel of major league baseball. On the other hand, Washington bustled with activity and although the war preoccupied the capital city, Senators enthusiasts were able to continue to enjoy the high quality of baseball by veteran greats like Cecil Travis and cheer for new stars like George Case, Dutch Leonard, and Mickey Vernon. The team was erratic at best, and by the end of the decade, Mr. Griffith would be disappointed but continued to beat the bushes for players who would keep the team from a slow but steady slide.

City fans were also able to witness the Negro League's Homestead Grays when they played at Griffith Stadium. The Grays, originally from Pennsylvania, featured Josh Gibson, Buck Leonard, "Cool Papa" Bell, Wilmer Fields, and others. Though they played some of their games at Forbes Field in Pittsburgh when the Pirates were out of town, they played most of their games at Griffith Stadium when the Senators were on the road. How good of a team were they? Many baseball historians say the Grays during the 1940s might have been the greatest professional ball club ever assembled.

The jewel in the Gray's crown was the best known of all the Negro League long ball sluggers, Josh Gibson. Gibson could win a game with one swing, a feat he did at Griffith Stadium for his team many times through the early and mid-1940s. Exact statistics are notoriously sketchy in trying to track any Negro Leaguers' precise record, but contemporary players unanimously give Josh his due. Buck O'Neil, famed first baseman and manager of the Kansas City Monarchs who played against Gibson many times and saw the great Negro and Major Leaguers in the 1930s and the 1940s, had this to say, "He was the best hitter I've ever seen. He would have rewritten the record book for homers had he played in the majors. He was our Babe Ruth." D.C. fans had the privilege of seeing Gibson play for much of the decade. Sadly, Gibson died in 1947 at the age of 36, the very year Jackie Robinson broke the major league color barrier.

WARTIME BASEBALL, 1941. As the clouds of war darkened the skies of our nation, the entire country, including baseball stars of the day like Cecil Travis, also prepared for war. Prior to serving with distinction in the United States Army, Cecil had a spectacular season with the Washington Senators in 1941. Not only did he hit an impressive .359 for the year, but his American League buddy and future war veteran Ted Williams would one day recall Cecil's play and say that he was as great of an all-around player as he ever played against. (B. Loughman.)

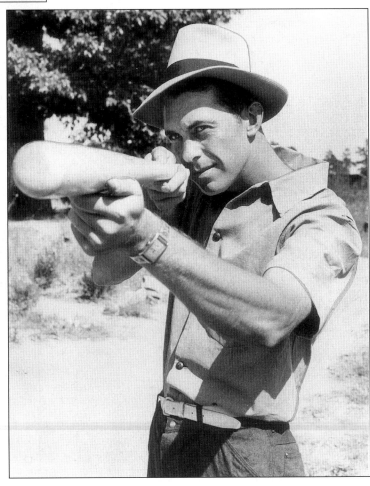

DUTCH LEONARD, C. 1940. Dutch Leonard was an outstanding Senators pitcher who won 190 games for four teams over a 20-year playing career. He had the misfortune of playing for the Senators from 1938 through 1946, a stretch in which the team posted losing seasons in all but two years. In fact, in 1940, Dutch had a respectable .349 earned run average but had no run support from the team and ended up losing a dismal 19 games. (T.G.)

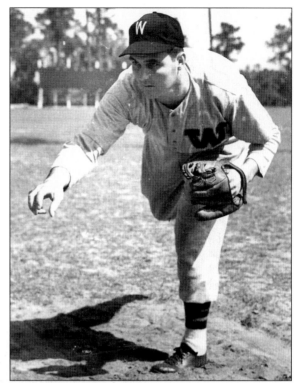

WASHINGTON INFIELD, 1941. Perhaps these Washington infielders look a bit pensive in this 1941 photo at Griffith Stadium. After all, they were to end up in sixth place in the American League that year, a whopping 31 games behind the New York Yankees. Pictured from left to right are George Archie, Buddy Lewis, Jimmy Pofahl, and Jimmy Bloodworth. (T.G.)

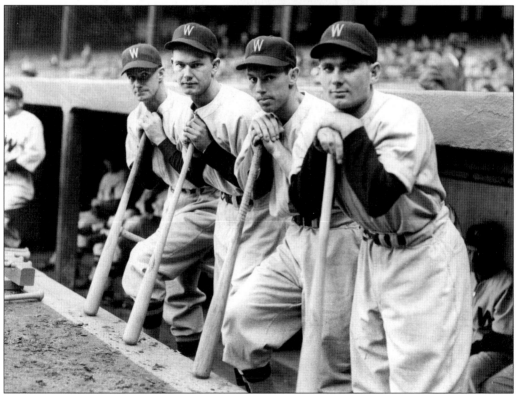

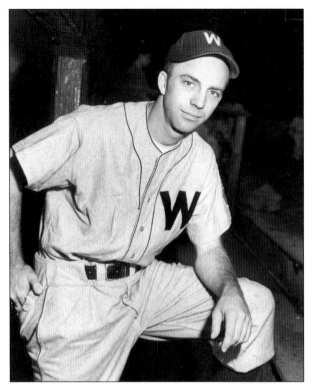

GEORGE CASE, 1942. George Case was a bright spot in some otherwise dreary years for the Washington Senators. George played for the team from 1937 through 1945, was elected to four All-Star Games, and hit over .300 for three seasons. He was also as fast as blazes. Senators' owner Clark Griffith, who observed major league ballplayers for more than six decades, said the speedy Case was as fast as any player he ever saw. (G. Case.)

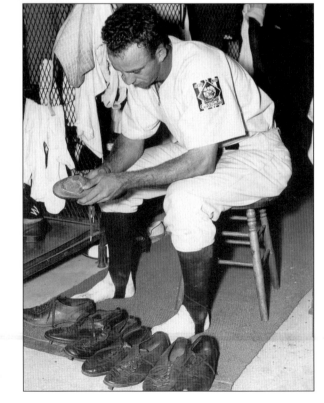

CHAMPION BASE STEALER GEORGE CASE. George's running shoes were very important to him, and he is shown here picking out a pair before a game in 1939. Note the Baseball Centennial patch George is wearing that celebrates baseball's 100th year. (B. Loughman.)

THE FASTEST MAN IN THE MAJORS: GEORGE CASE, 1943. On September 14, 1943, before a game against the Boston Red Sox, George Case broke the 40-year-old record for circling the bases. In the top photo, George is about to set the record, and in the bottom photo, owner Clark Griffith presents George with a $100 war bond for his efforts. (G. Case.)

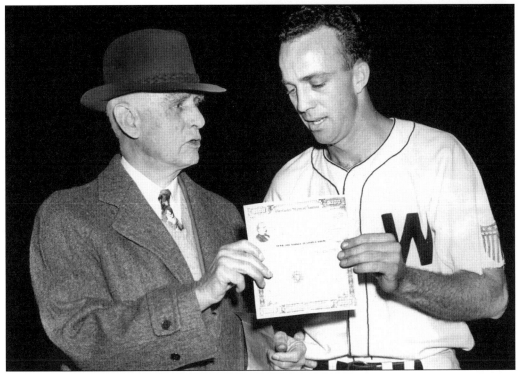

A Star on the Rise, c. 1942. Jimmy Trimble was a star pitcher at St. Alban's Prep School in Washington, D.C. in the early 1940s. He enjoyed spectacular success as the team captain and threw three no-hitters against tough opponents. After seeing Trimble pitch, Clark Griffith was so impressed with the hometown boy that he pledged to save the student a spot on the Senators' roster once he completed his education. However, in 1943 Trimble enlisted in the United States Marines and was sent to the island of Guam to fight for his country during World War II. (J. Roberts.)

Fallen Hero, 1945. On February 26, 1945, Jimmy Trimble's dream of pitching for the Washington Senators in the major leagues vanished when he was killed in fierce combat while fighting on the island of Iwo Jima. That spring Guam's military ball field, where Private Trimble had pitched for the Third Marine Division's All-Stars, was named in honor of the fallen military hero. (J. Roberts.)

THE WAR BEGINS, BUDDY LEWIS, 1942. On December 7, 1941, when Japanese forces bombed the United States Naval Base at Pearl Harbor, Hawaii, our country was thrust into the biggest war in its history. Life was changed for everyone including major league ballplayers. Under normal circumstances, Washington Senator Buddy Lewis would be at spring training in April of 1942, sharpening his baseball skills for the upcoming season. However, in this photo he and his fellow aviation cadets are seen checking out Buddy's glove at Kelly Air Force Field where they were being trained to fight in the Pacific theater. (B. Loughman.)

THE WAR CONTINUES, DUTCH LEONARD, 1944. One day after Christmas, on December 26, 1944, Washington Senator pitcher and full-time soldier, Dutch Leonard, was photographed signing autographs in France while surrounded by United States infantrymen anxious to return home. This photo was taken less than three weeks after D-Day. (B. Loughman.)

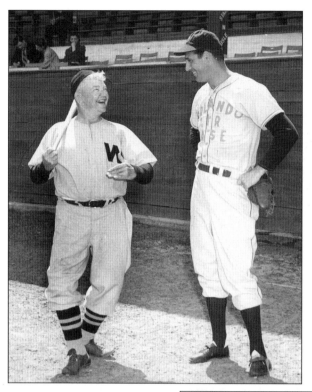

NICK ALTROCK AND SGT. HANK GREENBERG, UNITED STATES ARMY, 1942. Even major league baseball's greatest stars like Ted Williams, Bob Feller, and Hank Greenberg joined the service to fight for their country during World War II. Here Senators old-timer Nick Altrock is "marching" under the direction of Army trooper Sgt. Hank Greenberg prior to an exhibition game in Orlando, Florida. (T.G.)

SEAMAN SENATOR JAMES "MICKEY" VERNON, 1945. Mickey Vernon had been a standout player for the Washington Senators since 1939. In 1945, he joined the United States Navy. This photo was taken in the Marshall Islands where the "All-Navy Sports Caravan" featured three Washington-area sports figures. Pictured from left to right are Joe Wells, former pitcher from Georgetown University; Specialist First Classman Mickey Vernon; and Washingtonian George Abrams, the ex-middleweight boxing champion. (B. Loughman.)

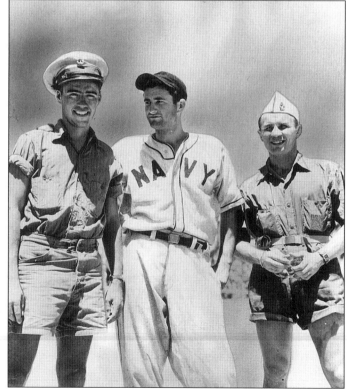

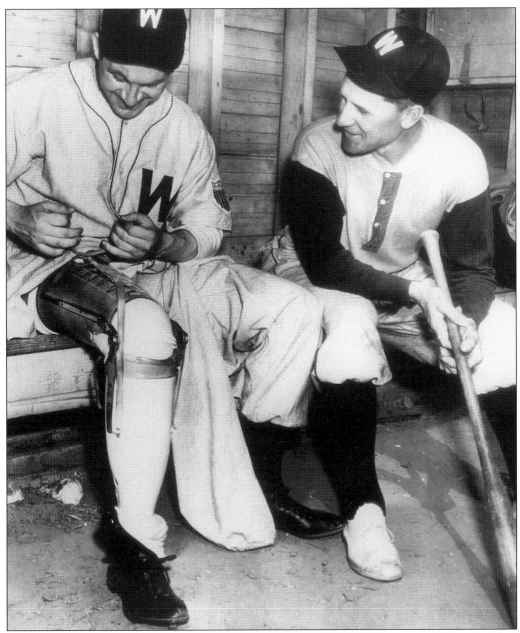

BERT SHEPARD, WAR HERO, 1945. Pitcher Bert Shepard was on his way to a distinguished professional baseball career in the early 1940s. After the attack at Pearl Harbor, however, Bert enlisted in the United States Army, and by 1944 he became a full-fledged fighter pilot. In May of that year, while on a mission in Europe, Bert's plane was shot down and the firepower literally ripped through his foot. He ended up losing the limb. After being bedridden in a prison camp and then returning to Walter Reed Hospital in Washington, D.C., the war hero still pined to play major league baseball. Clark Griffith obliged and arranged for Bert to finally pitch in an official American League game as a Washington Senator on August 4, 1945. He pitched well for five innings and gave up just three hits and a single run. Eleven days later World War II ended. (FC Associates.)

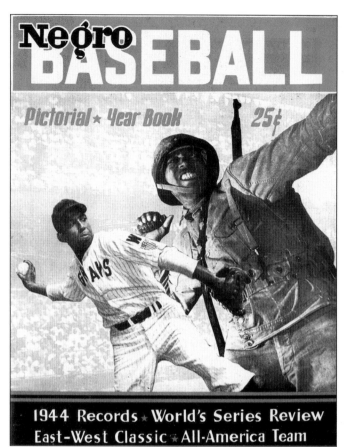

NEGRO LEAGUE YEARBOOK WITH BUCK LEONARD, 1945. From 1938 through 1950, Washington fans were fortunate because they were able to witness the Homestead Grays, one of the greatest professional baseball teams ever assembled, play at Griffith Stadium. Similar to the major leaguers, many prominent Negro League ballplayers were affected by World War II. This 1945 *Negro Baseball* yearbook features the great Buck Leonard as a ballplayer and throwing a grenade as a soldier. (FC Associates.)

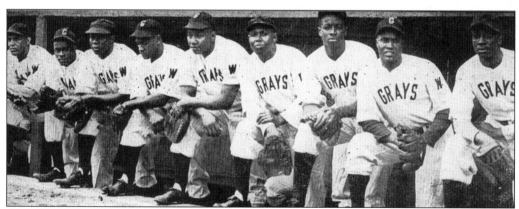

THE 1944 HOMESTEAD GRAYS. Washington's own Homestead Grays dominated Negro League baseball unlike any other team. From 1938 through 1948, the Grays won an unprecedented nine league championships. Pictured at their dugout in Griffith Stadium from left to right are Jelly Jackson, Ray Battle, Edward Robinson, Sam Bankhead, Josh Gibson, Buck Leonard, Dave Hoskins, Jerry Benjamin, and "Cool Papa" Bell. (T.G.)

HALL OF FAMER BUCK LEONARD, 1944. From 1934 until 1948, Buck Leonard, anchoring the middle of the lineup with Josh Gibson, played with the Homestead Grays. During the 1940s, he was the premier first baseman in all of baseball. Most baseball historians believe that Buck compared favorably with legendary New York Yankees former first baseman Lou Gehrig. Leonard was inducted into the Baseball Hall of Fame in 1972. (T.G.)

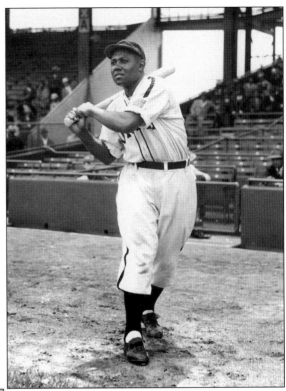

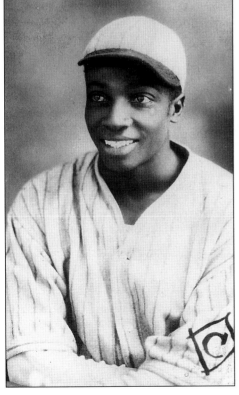

HALL OF FAMER JAMES "COOL PAPA" BELL. Cool Papa Bell, a lifetime .341 hitter, played for, amongst other teams, the Pittsburgh Crawfords and Homestead Grays from 1922 through 1946. He was known as a speed demon on the bases. Satchel Paige enhanced Cool Papa's legendary moves by claiming that Bell could snap off the light switch at his doorway and be in bed under the covers and ready to sleep before the room darkened. Bell played with Josh Gibson, Buck Leonard, and others for several years during the Grays' heyday at Washington's Griffith Stadium during the 1940s. (FC Associates.)

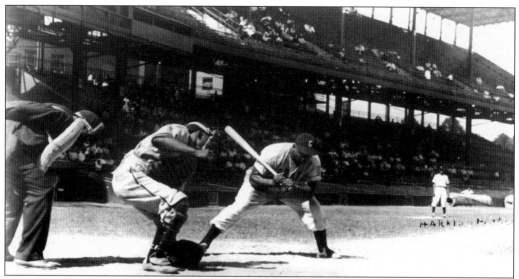

HALL OF FAMER JOSH GIBSON. Catcher Josh Gibson is said to have been the greatest long ball hitter of all time. Along with teammate Buck Leonard, Gibson powered the Pittsburgh Crawfords and Homestead Grays for his entire career. Negro League historian John Holway correctly notes that Gibson's batting feats were mythical and his power was legendary. Holway documents that between 1930 and 1945, Gibson batted .351 and led the Negro Leagues in homers every year except for two even though he played for the Grays at cavernous Griffith Stadium. Some of those homers were monstrous shots. Gibson tragically died shortly before Jackie Robinson broke the color barrier in 1947. He was inducted into the Baseball Hall of Fame in 1972. (T.G.)

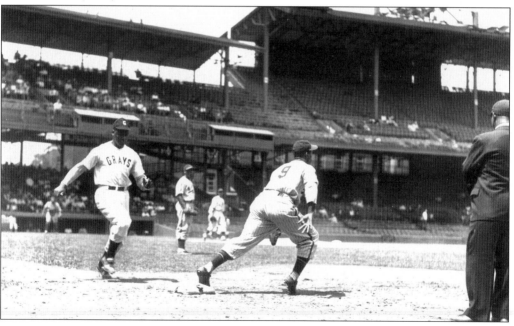

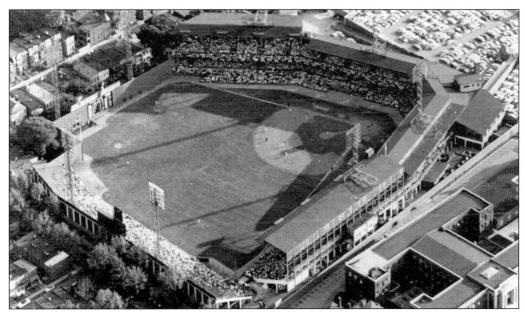

GRIFFITH STADIUM, C. 1940S. National Park, sometimes called the Washington Baseball Club Park, from 1891 on hosted thousands of professional baseball games in Washington, D.C. for over six decades. It became known as Griffith Stadium in 1920, named after owner Clark Griffith and was home to the Washington Senators. The Homestead Grays played there from 1938 until 1950 on Sundays when the Senators were on the road. By that time, after some alterations, it measured a staggering 402 feet down the left field line and the deep center field wall was 421 feet from home plate. It was said to be a hitter's nightmare, and, in fact, only three home runs were ever hit *over* the left field bleachers at Griffith Stadium—Mickey Mantle did it once in 1953, a 565-foot bomb that is the official major league record, and Josh Gibson did it twice during the 1940s. (Martin Luther King Library.)

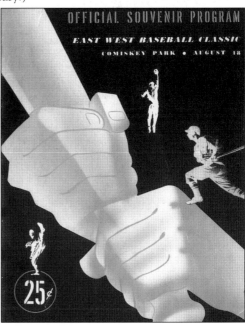

NEGRO LEAGUE EAST-WEST GAME, 1946. For many years the Negro League's premier game was the annual East-West All-Star Game. In 1946, the East lineup featured Washington's own Buck Leonard, Josh Gibson, and Sam Bankhead. Also pitching for the team was the Newark Stars future Hall of Famer and Baltimore native Leon Day. (FC Associates.)

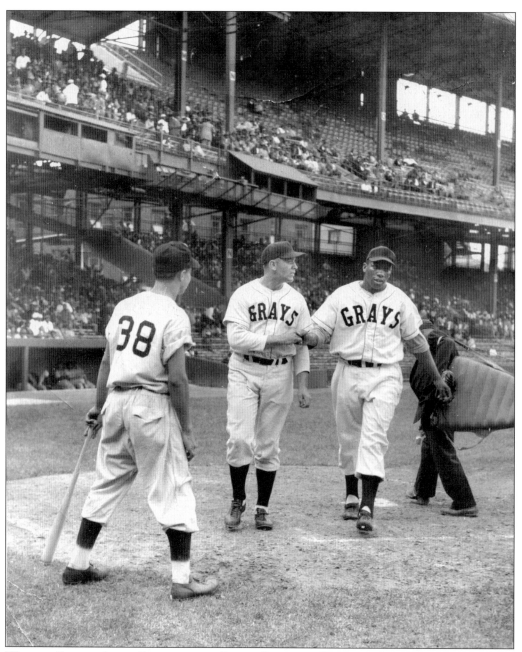

WILMER FIELDS, LUKE EASTER, AND BILLY COWARD, GRIFFITH STADIUM, 1947. In the summer of 1947, Homestead Grays slugger Luke Easter is greeted by teammate Wilmer "Red" Fields and batboy Billy Coward after hitting a booming home run. Luke Easter eventually made it to the major leagues and Red Fields had several offers to do so but declined. Fields had a distinguished baseball career, not only as a batter who hit .400 in 1948, but also as a pitcher who that same year won the decisive game for the Grays when they captured the Negro League World Series Championship. He also served in the United States Navy with distinction during World War II. (B. Coward.)

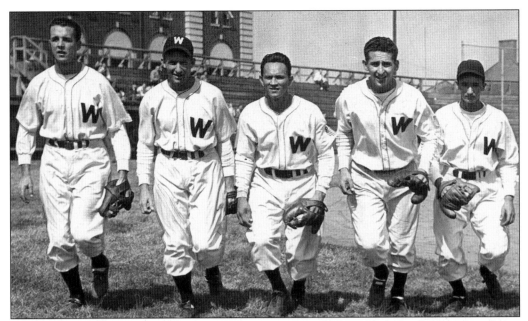

THE CUBAN SENATORS, 1945. During the war years and after, Clark Griffith was not shy in opening the doors to Cuban ballplayers for his roster. Many would only make it through part of the spring training, but Griffith had a penchant for giving opportunity to many ballplayers from the island. Pictured during the 1945 preseason, from left to right, are Armando Gallert, Anglo Fleitas, Manuello Hidalgo, Louis Argara, and Augustine Delaville. (B. Loughman.)

A YOUNG EARLY WYNN, C. 1946. Early "Gus" Wynn spent his first nine years pitching for the Washington Senators. After winning only 72 games while losing 87, he was traded in 1948 to the Cleveland Indians. The trade was known as "Thelma's Deal," because Thelma, Clark Griffith's daughter, was married to Joe Haynes, the Cleveland player given up for Wynn. Thelma, it is said, preferred to live in Washington, D.C. and made her views known to her father. The trade was a steal—for Cleveland, that is. Haynes would win a total of 10 more games for the Senators while Wynn notched 238 additional victories and became enshrined in the Baseball Hall of Fame. (T.G.)

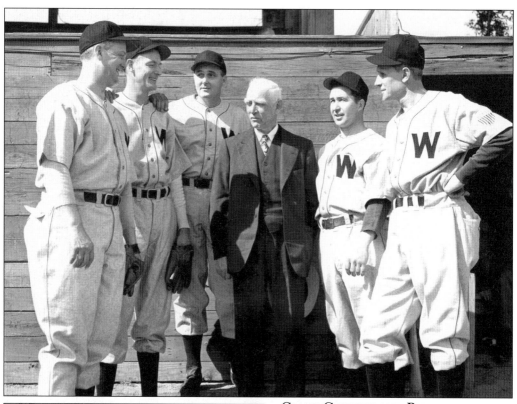

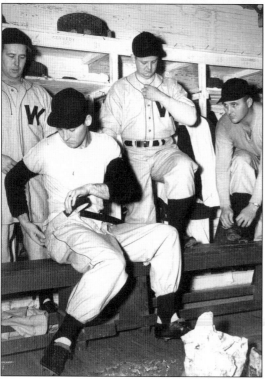

CLARK GRIFFITH AND PITCHERS FOR 1946 SENATORS. Senators' owner Clark Griffith and manager Ossie Bluege had every reason to be optimistic after a good season in 1945. After all, the Senators came within one game of winning the American League Pennant primarily because of their strong starting pitching rotation. Pictured from left to right are Roger Wolff (20 wins in 1945), Sid Hudson, Dutch Leonard (17 wins in 1945), Clark Griffith, Milt Haefner (16 wins in 1945), and Ossie Bluege. But the smiles would be gone from the players' faces by the end of the 1946 season. (T.G.)

END OF THE YEAR BLUES, 1946. These four hurlers, photographed in the dressing room at Griffith Stadium after the last game of the 1946 season, are disappointed because the team had a losing season for the year. Alas, they won 76 ballgames but lost 78. Pictured from left to right are Milt Haefner, Bill Kennedy, Roger Wolff, and Dutch Leonard. (T.G.)

JOE DIMAGGIO AND A CLOWNING AL SCHACHT, 1948. Rumors were that Joe DiMaggio and all-around Washington Senator employee and comedian Al Schacht would do a radio show together after the 1948 season. They didn't, but Al went on to New York anyway . . . to run his own restaurant. (B. Loughman.)

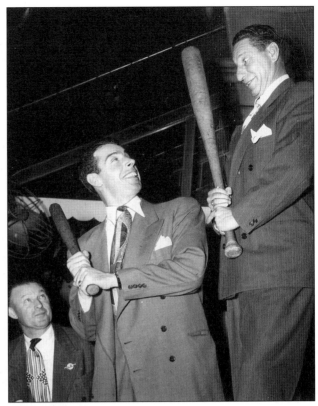

"WHEN IT COMES TO FOOD—I'M NOT CLOWNING," C. 1940S. The menu for Al Schacht's restaurant featured sirloin steak for $4.25, frog legs for $3.50, and crab meat au gratin for $3.95. (FC Associates.)

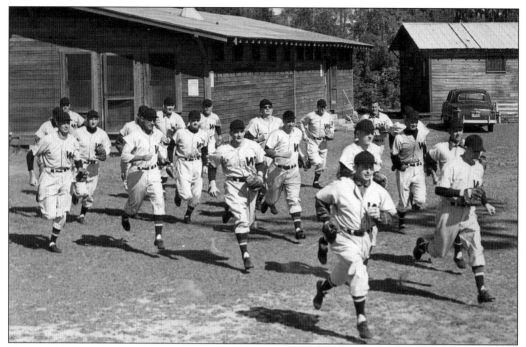

THE 1949 PRESEASON IN FLORIDA. Maybe it was the Florida sun that made these players enthusiastic before the upcoming 1949 major league baseball season. However, manager Joe Kuhel was openly pessimistic from the very beginning of the year. Hope springs eternal, however, and Kuhel thought that perhaps a strong pitching staff would give the team a fighting chance to challenge the Yankees and Red Sox in the American League. (B. Loughman.)

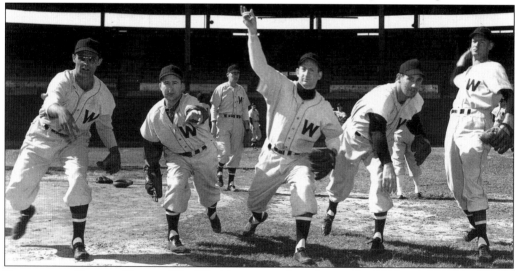

END OF THE DECADE GLOOM. The Washington pitchers during the 1949 season were thought by the Senators brass to possibly off-set their teammates weak bats. They didn't; the team lost a whopping 104 games—their worst showing in 40 years—and manager Joe Kuhel was fired. By the end of the decade, things looked bleak for professional baseball in Washington. Not only would the great Homestead Grays team disperse and end their several-year championship reign, but the Senators continued to play downright badly. (B. Loughman.)

Five

THE LEAN YEARS
1950s–1960

For all but one season during the 1950s, the Washington Senators would post losing records. Although the venerable Clark Griffith would continue to strategize with manager Bucky Harris and search for a winning combination of players that would enable his team to challenge perennial winners like the New York Yankees, by the time "the Old Fox" passed away in late 1955 the team would still be mediocre at best.

However, professional baseball still excited the fans at Griffith Stadium and the faithful were treated to a new group of skilled hometown ballplayers like "the Walking Man" Eddie Yost, slugger Mickey Vernon, Harmon "the Killer" Killebrew, and home run hitter Bobby Allison. Also, the Senators' "Cuban Connection" continued in earnest with the addition of pitchers "Connie" Marrero, Pedro Ramos, and fireballer Camilo Pascual.

Also, because baseball was enjoying a time that is fondly recalled as being the game's "golden age," visiting American League teams provided fans an endless roster of highly talented ballplayers who regularly played the Senators at Griffith Stadium. The Yankees, of course, boasted Joe DiMaggio, Yogi Berra, and Whitey Ford. No sooner did Joltin' Joe retire in the early 1950s did the new Yankee phenom from Commerce, Oklahoma, Mickey Mantle, quickly capture the hearts of fans everywhere. In fact, Mantle holds the official record for major league baseball's longest home run when he blasted a 565-foot shot in front of a D.C. crowd at Griffith Stadium. So too, the visiting Boston Red Sox showcased the game's premier batsman Ted Williams, the Indians touted Larry Doby and Rocky Colavito, and the Detroit Tigers would visit town with future Hall of Famer Al Kaline.

As the 1950s came to a close, frustration reached its peak. Clark's son and new owner, Calvin Griffith, sought to move the team for several years after assuming ownership, and his annual request was finally approved by the league in late 1960. Thus, the original Washington Senators American League franchise, with its storied history, ended after 60 years in the nation's capital.

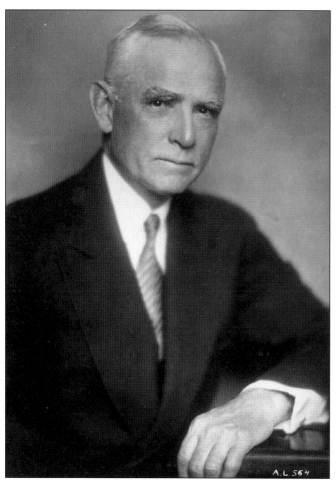

CLARK GRIFFITH STUDIO PHOTO. By 1950, Clark Griffith had either been a professional baseball player, team manager, or owner for over 50 years. Unfortunately for city fans, his beloved Washington Senators team started out the decade struggling against other American League teams like the New York Yankees, Boston Red Sox, Cleveland Indians, and Detroit Tigers. However, Griffith was still able to put some excitement in professional baseball in Washington, D.C. by bringing to the city several exceptional ballplayers. (B. Loughman.)

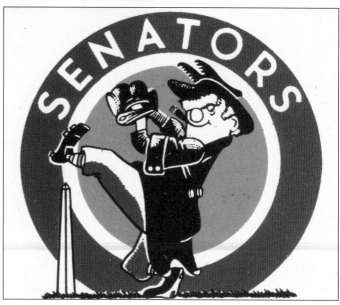

THE 1950S WASHINGTON SENATORS LOGO. (T.G.)

EDDIE YOST, "THE WALKING MAN," 1950. Eddie Yost played 14 years with the Washington Senators. By the end of 1950, he became known as the Walking Man because of his ability to get on board at first base by drawing walks a staggering 141 times for the season. Beginning that year, Yost coaxed bases on balls over 100 times for five straight seasons, eventually doing the same eight times during his career. His battles with the game's best pitchers and on the base paths during the 1950s were legendary. (T.G.)

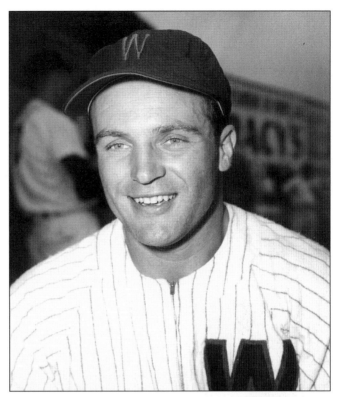

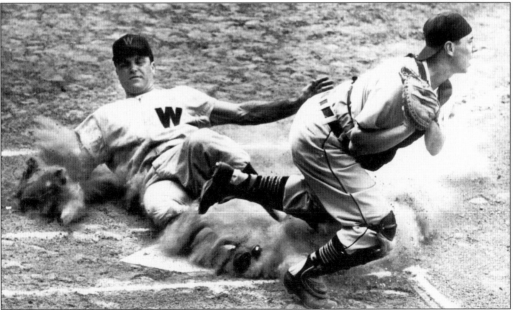

EDDIE YOST SCORES, 1952. After walking during this game against the Detroit Tigers in 1952, Yost stole second base and was able to round third and score on a teammate's single. "The Walking Man" ended up on base even more than players like Ted Williams and Mickey Mantle during the early 1950s. In 1950, his on-base percentage was a league-leading and staggering .440. (T.G.)

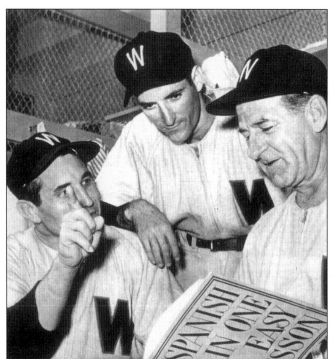

SPANISH IN ONE EASY LESSON, 1950. Manager Bucky Harris was hoping to improve his team's pitching in 1950 after they won only 50 games the previous year. Here he welcomes to the pitching staff Cuban Conrado Connie Marrero, a knuckleballer who reported his age at 33, although many from the major leagues remembered facing him in Cuba in the mid-1930s. Because of his carefree ways and happy-go-lucky attitude, Marrero became popular with the fans, his teammates, and the Washington media. Pictured from left to right are Connie Marrero, fellow newcomer Sandy Consuegra, and manager Bucky Harris. (T.G.)

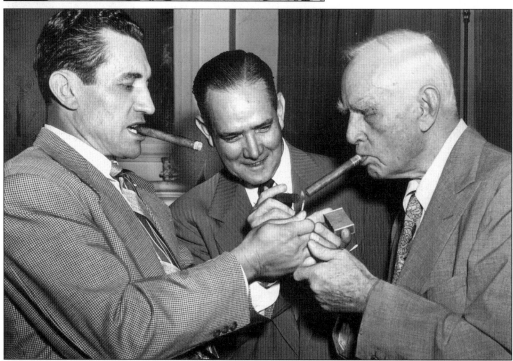

IT'S PARTY TIME, 1951. Despite their losing ways, the Griffiths often hosted barbecues and parties for their team and their new recruits during the early 1950s. Here Clark Griffith enjoys a Cuban cigar with fun-loving Connie Marrero, right, and Cuban Ambassador Machado in downtown Washington, D.C. (T.G.)

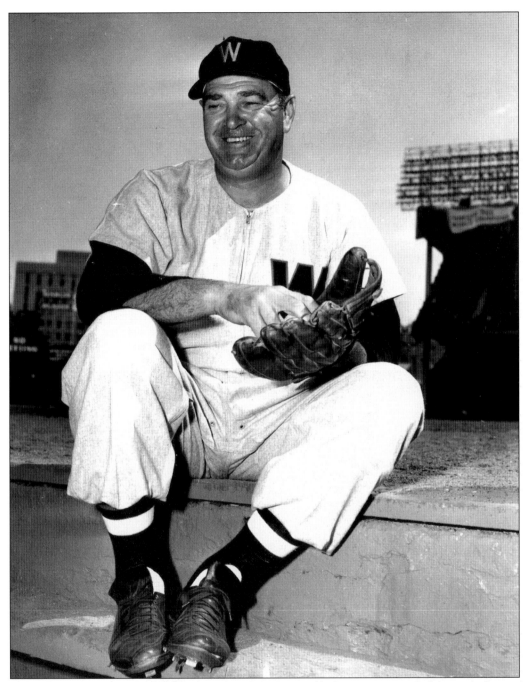

BOBO NEWSOM, 1952. Bobo Newsom played professionally for 26 years, including several stints with the Washington Senators beginning in 1935. Mr. Griffith had an up-and-down relationship with Bobo, as he would either buy or trade for the hurler on five different occasions. Although he pitched 211 victories during his long major league career, he lost 222 games. Here, Bobo is pictured smiling broadly during his final stay with the Senators in 1952. He ended up with only one victory for the team that year, was shipped off to Philadelphia, and ended his long playing career. (T.G.)

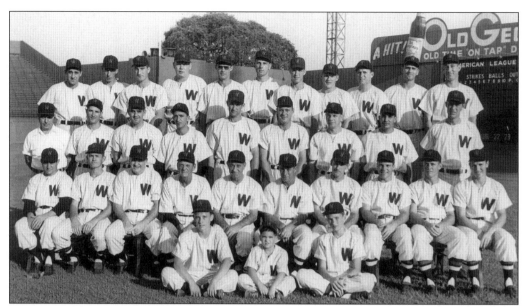

THE 1953 WASHINGTON SENATORS. Although the team came in fifth place in the American League for the 1953 season, winning 76 games but losing the same amount, the team did feature several excellent players like Mickey Vernon, Eddie Yost, Jackie Jensen, Pete Runnels, and pitchers Bob Porterfield and Walt Masterson. (T.G.)

BOB PORTERFIELD WINS ANOTHER, 1953. Pitcher Bob Porterfield had a spectacular season for the Washington Senators in 1953. He won 22 games while losing only 10 and notched nine shutouts. *The Sporting News* selected Porterfield to be their "American League Pitcher of the Year." Here Porterfield celebrates his second one-hitter of the season on June 10, 1953 with teammates Keith Thomas (left) and Mickey Vernon (right). (T.G.)

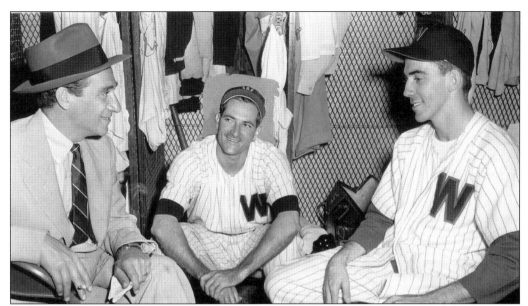

SHIRLEY POVICH: WASHINGTON'S PREMIER SPORTS WRITER. Shirley Povich covered the Washington Senators and baseball in general for *The Washington Post* for over seven decades. Shirley was a Washington institution whose popularity rivaled even the most famous of baseball players. Here two Cuban ballplayers, Miguel Fornieles who hurled a one-hitter in his 1952 debut at Griffith Stadium and fellow countryman Sandy Consuegra, enjoy chatting with the eminent sports writer in the team dressing room. (B. Loughman.)

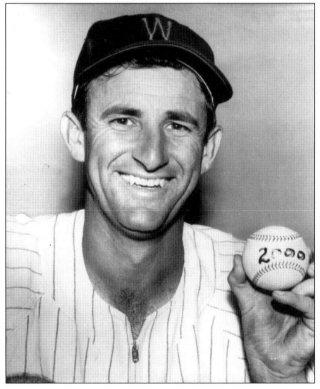

MICKEY VERNON, 1954. On July 8, 1939, amiable 21-year-old first baseman Mickey Vernon made his first appearance as a Washington Senator. He ended up playing over 2,400 games for several teams but spent most of his time as a professional ballplayer in Washington. Mickey was a great hitter and would win the American League batting title twice and lead the league in doubles three times while wearing a Senators uniform. When he retired, he held the major league record for the most games played at first base. Here Mickey, in September of 1954, shows off his 2000th hit baseball. He would manage the Senators after his retirement as a player. (T.G.)

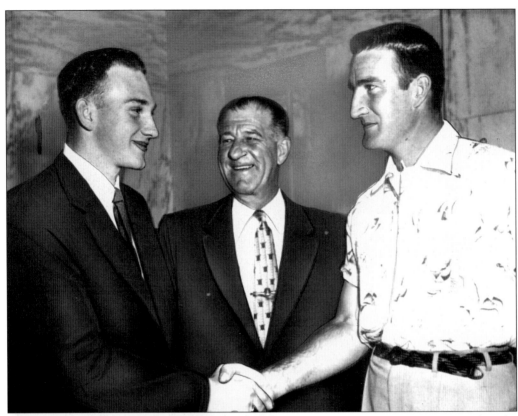

Ring In the New, 1954. Even though Harmon Killebrew, fresh from Idaho, was signed by the Washington Senators in 1954, he only played three games at second base, an unfamiliar position, for the year. By year's end, manager Bucky Harris would be gone and it would be several years before Killebrew started to put up Hall of Fame numbers at the ballpark. Pictured, from left to right, are a youthful Harmon Killebrew, a smiling Bucky Harris, and veteran Bob Porterfield welcoming the Idaho strong boy. (B. Loughman.)

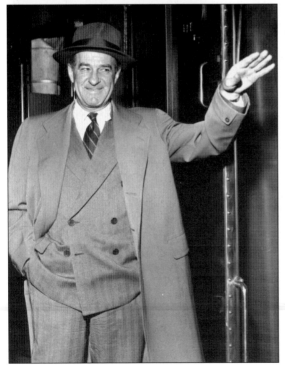

Bucky Says Goodbye, 1954. In 1954, Bucky Harris's team managed only 66 victories while losing 88. That was enough for an aging Clark Griffith, who released his old faithful friend at season's end. Here, after three different managerial stints with the Senators covering a span of 40 years, Bucky waves goodbye to the team . . . at least for a while! (T.G.)

CONNIE MACK AND CLARK GRIFFITH, 1955. By the time "the Tall Tactician" and "the Old Fox" were to meet in early 1955, they had accumulated over a century of combined baseball wisdom between them. Mack, when he was known as Cornelius McGillicuddy, caught for the Washington Nationals at the old Swampoodle Grounds almost 70 years earlier. Griffith either managed or owned the Senators team during their entire American League existence. Mr. Griffith passed away on October 27, 1955. Mr. Mack passed away the following year on February 8, 1956. Both of them are members of the Baseball Hall of Fame. (P. Peterson.)

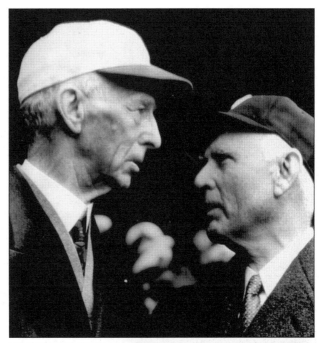

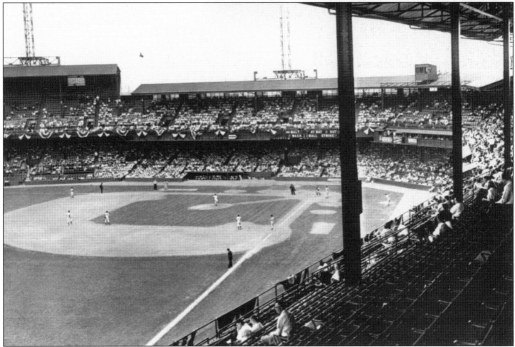

THE 1956 ALL-STAR GAME AT GRIFFITH STADIUM. In commemoration of Clark Griffith's long and distinguished career in major league baseball, the 1956 All-Star Game was officially titled "The Clark Griffith Memorial All-Star Game." The thrilling 1956 All-Star Game was played at Griffith Stadium in Washington, D.C. Although the National League won 7 to 3 with clutch hitting by Stan Musial and Willie Mays, the fans were treated when Ted Williams and Mickey Mantle both hit long home runs for the American League. (T.G.)

DICK HYDE. Known as much for his glasses as his unusual submarine pitch and delivery, moundsman Dick Hyde played five years for the Washington Senators. In 1957, the team came in last place in the American League winning a dismal 55 games. The next year, with Hyde leading the American League with 10 relief victories, the team improved to a meager 61 victories. However, they still came in last place. (T.G.)

THREE GENERATIONS, 1959. Washington would again come in last place in the American League for the 1959 season. However, slugger Roy Sievers gave Washington fans something to cheer about as he hit over 90 home runs during a three year span to close out the 1950s. Here, on Old Timers Day in 1959, Sievers is surrounded by Hall of Fame greats Goose Goslin (left) and Sam Rice (right). (T.G.)

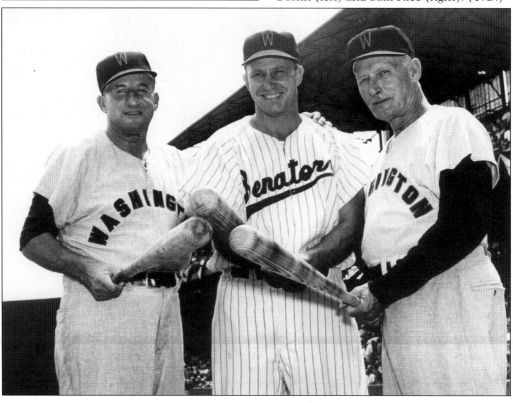

"THE KILLER," 1959. Although it took Harmon Killebrew five years to truly have a breakout season with the Washington Senators, he certainly did so in 1959 when he began to play regularly for the team. He led the league with 42 home runs and had 105 RBIs. By the time Harmon ended his career, he would amass 573 career homers with over 2,000 hits for the Senators and Minnesota Twins. He ended his career in 1975 with the Kansas City Royals. (T.G.)

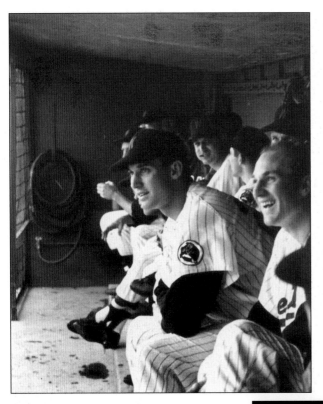

HARMON KILLEBREW AND BOBBY ALLISON, 1959. Bobby Allison and Harmon Killebrew had every reason to smile during the 1959 major league baseball season. Between them, they hit 72 home runs for the Washington Senators, many of them coming in front of the Washington faithful at Griffith Stadium. Here the boys are smiling with other teammates in their hometown dugout. (T.G.)

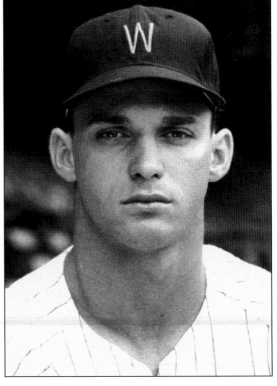

BOBBY ALLISON. Bobby Allison played 13 years in the major leagues, first for the Washington Senators and then for the Minnesota Twins. He ended his career with 256 home runs. Allison and teammate Harmon Killebrew, who played together in Washington and Minnesota, made for a powerful slugging duo. (T.G.)

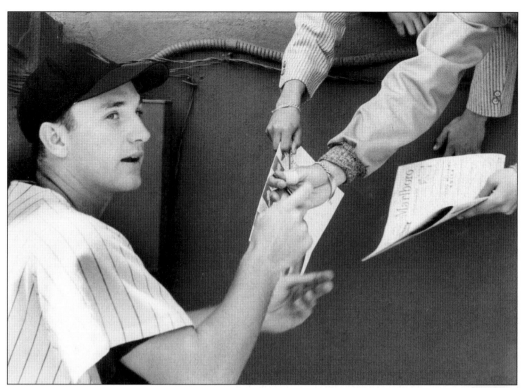

FAN FAVORITE HARMON KILLEBREW. Because Harmon Killebrew blasted gargantuan home runs in American League parks throughout the country, he was a particular fan favorite. Here Harmon signs scorecards for young fans at Griffith Stadium. (T.G.)

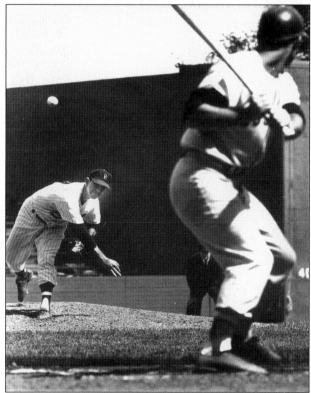

"THE LITTLE POTATO," CUBAN CAMILO PASCUAL. When Camilo Pascual first played for the Senators beginning in 1954, the Cuban-born pitcher had several rather mediocre seasons. After four years, however, he developed a wicked curve ball, eventually won 174 major league baseball games, and led the league in strikeouts for three consecutive seasons. The Little Potato was always a cool customer, and the fans in Washington loved him. (T.G.)

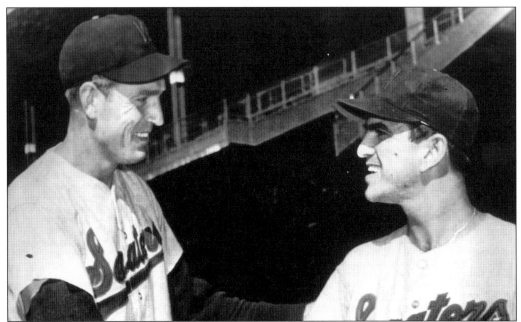

JIM LEMON AND CAMILO PASCUAL, 1960. Jim Lemon led the Washington Senators with 38 home runs and 100 RBIs in 1960 while Camilo Pascual had a solid 12-victory season. They were two bright spots in the original Washington Senators' final year. Here Jim Lemon hands over the game-winning ball to a smiling Camilo Pascual. (T.G.)

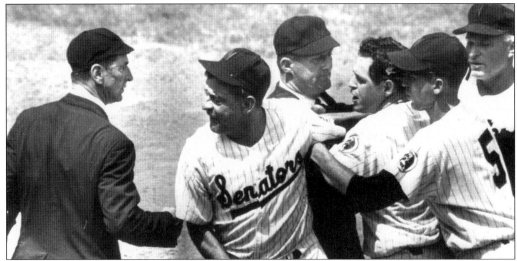

COOKIE LAVAGETTO AND PEDRO RAMOS, 1960. The year 1960 was a frustrating and bittersweet year for manager Cookie Lavagetto, the Washington Senators team, and their faithful fans. Workhorse Pedro Ramos pitched a team-leading 274 innings yet posted 18 defeats for his trouble. Here manager Lavagetto separates an enraged Pedro from the umpire during a game at Griffith Stadium. Not only would the team have another losing season, but on October 26th, at a meeting behind closed doors in New York City, the major league owners granted Senators owner Calvin Griffith's request to move his team to Minneapolis, thereafter called the Minnesota Twins. However, at the same time, the league owners carved out a new expansion franchise for the City of Washington. (B. Loughman.)

Six

THE EXPANSION
SENATORS
1961–1971

After the Senators relocated to Minneapolis to become the Twins, on November 17, 1960 the city of Washington was awarded a new expansion team. The owners were a group of ten hastily assembled local investors. They were headed by Elwood "Pete" Quesada, an administrator of the Federal Aviation Administration who knew little of the nuances of the game of baseball. Immediately the group hired a staff of baseball men, the team was stocked with ballplayers made available from the first major league expansion draft, and the "new" expansion Senators opened their first training camp raring to go on February 22, 1961. However, the expansion club could never really find its bearings and the decade was replete with "fits and starts."

Except for the year that the great Ted Williams was lured out of retirement to manage the Washington Senators in 1969 and led the team to an exciting winning season, the decade of the 1960s—the team's last in Washington D.C.—would be a mixed bag at best. Although the expansion team suffered through losing seasons in each of their first eight years, fans did have plenty of reason to cheer their hometown heroes. The average Joe was able to join congressmen and the even the President himself to witness the legendary long ball hitting of "the Capital Punisher," big Frank Howard; they were treated to some heady pitchers like Dick Bosman and spirited play by Washington's own Chuck Hinton, Ken McMullen and others; and they witnessed one of baseball's most spectacular outings ever by a pitcher, the 21-strikeout masterpiece painted by Senators hurler Tom Cheney.

To most who lived through the time period, however, the decade will forever be linked to the sad reality of professional baseball in Washington . . . it would be a time in which the hometown professional ball club, one that was amongst the first organized ball clubs in the country and part of the first eight franchises that made up the American League at the turn of the century, would slowly but surely sink deeper and deeper into despair, until suddenly, the team left and is now but a distant memory.

(*above left*) WASHINGTON SENATORS SCORECARD, D.C. STADIUM INAUGURAL YEAR. This game program was sold to spectators in 1962 at D.C. Stadium, the new home of the expansion Senators. It contained each game's rosters, the year's schedule, and current news about the teams and their stars. (T.G.)

(*above right*) WASHINGTON SENATORS SCORECARD, D.C. STADIUM. This AL official scorecard features the expansion Senators' ballpark, D.C. Stadium. Now called Robert F. Kennedy Stadium, the stadium still sits by the Potomac River near the armory. (FC Associates.)

THE 1960s WASHINGTON SENATORS LOGO. (T.G.)

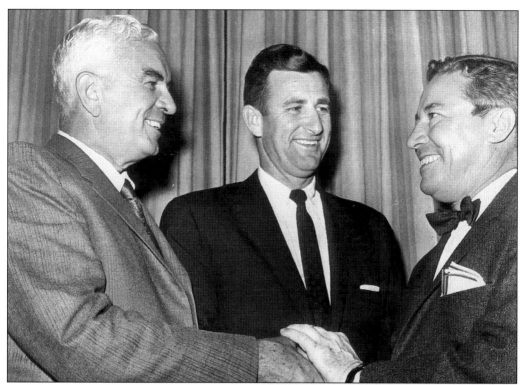

A FAMILIAR FACE FOR THE NEW FRANCHISE, 1960. Less than a month after the old Senators moved to Minnesota, the new expansion team brass began to quickly assemble their managerial team. This photo shows General Manager Ed Dougherty, left, and new majority owner of the Washington Senators expansion franchise Pete Quesada, right, welcoming former Senators star Mickey Vernon (center) to manage the new team. (B. Loughman.)

BENNIE DANIELS. After several years pitching for the Pittsburgh Pirates in the National League, the new expansion Senators made their first trade by swapping a draft pick for 20-year-old Bennie Daniels. In 1961, he led the team with 12 victories. In 1962, Bennie pitched and won the opening game at the new D.C. Stadium, a nifty five-hitter, as President John Kennedy cheered him on. Daniels would end up playing three more years for the Senators. (B. Loughman.)

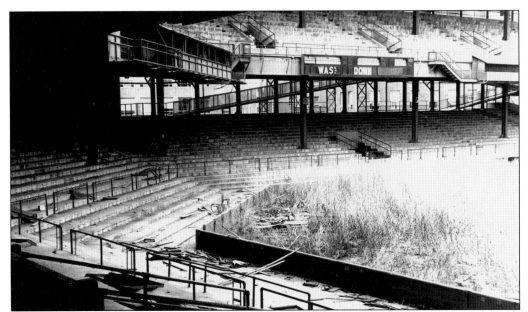

GRIFFITH STADIUM DEMISE, 1961. Even though Washington's Griffith Stadium witnessed the pitching exploits of the great Walter Johnson, three World Series contests, outstanding Negro Leaguers like Josh Gibson and Buck Leonard, and two All-Star Games, only 1,498 fans showed up to see the last game at Griffith Stadium on Thursday, September 21, 1961. Typical of a year in which the expansion team would lose an even 100 games, the Senators lost and, in an ironic twist, Harmon Killebrew, now with the Minnesota Twins, would score the last run ever at Griffith Stadium to assure victory for his new team. Killebrew hit the most home runs—363— of any major leaguer during the 1960s. (Martin Luther King Library Collection.)

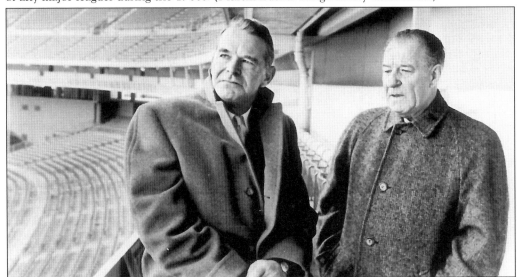

BIRTH OF A NEW STADIUM. Like a revolving door that never stopped, Bucky Harris was once again hired for special assignments by the expansion Washington Senators. This photo shows General Manager George Selkirk, left, showing Bucky D.C. Stadium, the home for the new Senators. The stadium would later be renamed R.F.K. Stadium following the assassination of Robert F. Kennedy in 1968. (B. Loughman.)

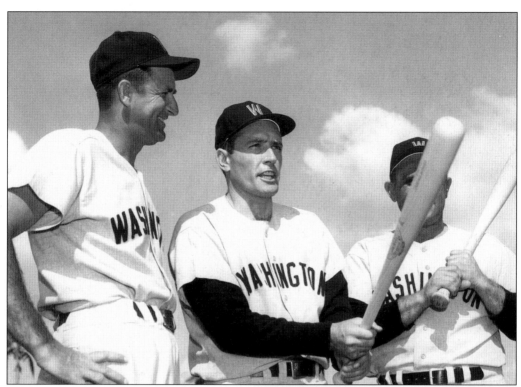

A NEW TEAM, 1962. No combination of trades for aging veteran players could help the managerial tenure of former Washington Senators player Mickey Vernon. His teams would lose at least 100 games in each of the three years he managed the team—1961, 1962, and 1963. Here Mickey Vernon, left, welcomes new Senator and well-known character Jimmy Piersall, center. Also pictured, behind the baseball bat, is slugger Gene Woodling, who batted .313 for the Senators in 1961. (B. Loughman.)

TOM CHENEY'S MASTERPIECE, 1962. From 1961 through 1966, pitcher Tom Cheney only won 18 games for the Washington Senators. However, on September 12, 1962, Cheney accomplished what many consider to be one of the greatest single game pitching achievements in baseball history when he struck out 21 Baltimore Orioles in a 16-inning game. This is still a single game strike out record. (FC Associates.)

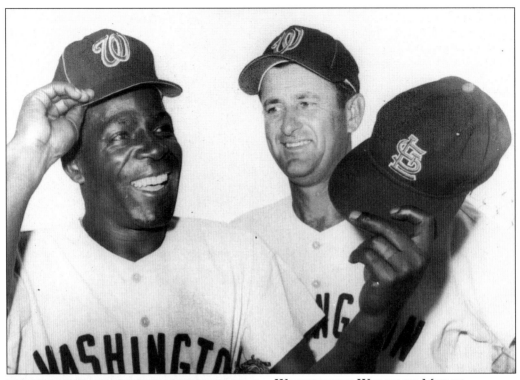

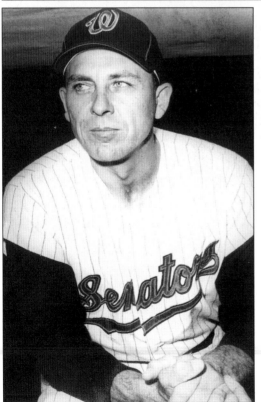

WASHINGTON WELCOMES MINNIE MINOSO, 1963. Orestes Armas "Minnie" Minoso, from Cuba, played 17 solid years in the United States for various major league baseball teams. Mickey Vernon, again hoping to jumpstart the expansion franchise, traded for Minnie in 1963. He only lasted through the year with the team while hitting .229, a good 60 points below his lifetime batting average. By the end of the 1963 season, manager Mickey Vernon was also gone and former New York Dodgers star Gil Hodges was hired to replace him. (T.G.)

GIL HODGES, 1963. In an attempt to shake things up at the end of 1963, the Senators fired Mickey Vernon and replaced him with former Dodger great Gil Hodges. Things didn't start out well for the new manager as his team lost nine of his first ten games, won four, then dropped another ten! Sadly, things never really improved. Hodges' four-and-a-half-year tenure in Washington was not successful as the team would come in near the bottom of the American League standings for each of those years. (T.G.)

FRED VALENTINE, 1964.
Manager Gil Hodges was hoping that former Baltimore outfielder Fred Valentine, who was hitting over .300 for the Orioles, could provide stability on his weak-hitting team. It was not to be. Fred played four-and-a-half average years in Washington, but the team's record was still mediocre at best. In mid-1968, he was traded back to Baltimore. (FC Associates.)

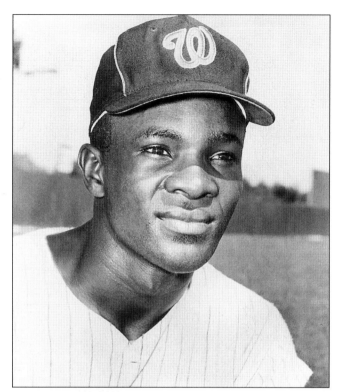

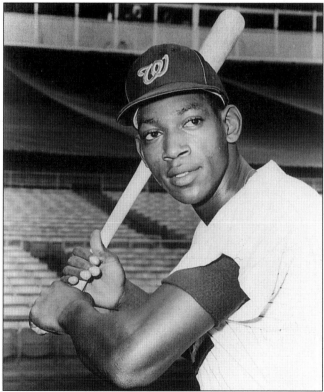

PAUL CASANOVA, 1966.
Cuban Paul Casanova was the catcher for the Washington Senators from 1965 until major league baseball left the city in 1971. Although he was not known as a strong hitter, his defensive skills were solid, and he was to gain fleeting fame when on June 22, 1966, he scored the winning run and the last-place Senators beat the White Sox in the 22nd inning of a night game. That was the longest game in major league history, a record that has since broken. (FC Associates.)

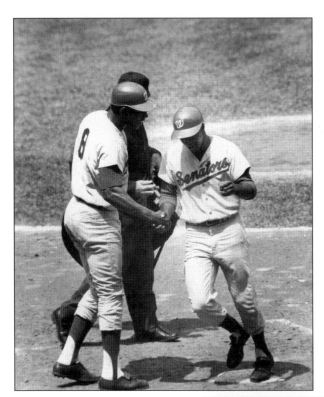

SENATORS AT YANKEE STADIUM, 1968. This photo shows Washington Senator Ed Stroud after hitting a home run in the fifth inning of the first game of a doubleheader against the New York Yankees on May 30, 1968. Catcher Paul Casanova meets Stroud as he crosses home plate. This was one of the few bright spots during a game on the road in an otherwise dreary season. (T.G.)

SID HUDSON, 1968. Even though the Senators players and owners were willing to give manager Gil Hodges more time, by the end of the 1967 baseball season he was pining to return to his home in New York City. After Hodges confirmed rumors that he was offered a manager's slot with the New York Mets, Jim Lemon replaced him as manager, and former Washington pitcher and coach Sid Hudson was re-hired. Hudson had won over 100 games for the Senators during the 1940s and would last as a coach with the team until they left D.C.. (FC Associates.)

JIM HANNAN, 1968. Pitcher Jim Hannan played in Washington for most of his 10-year career. Hannan's best year was in 1968 when he won 10 games for the Senators. Two years later, he would be part of one of the most controversial trades in Senators' history when the team, under the insistence of owner Robert Short, obtained the services of Detroit Tigers bad boy, Denny McLain, who had notched over 50 victories for the Tigers in 1968 and 1969. McLain would only win a total of 10 games for the Senators and end his career in baseball by 1972. (FC Associates.)

DICK BOSMAN, 1968. From 1966 on, pitcher Dick Bosman was to be in the starting rotation for the Washington Senators. In 1968, even though Dick's earned run average was a respectable 3.69 runs per game, the team's dreadful hitting was responsible for the fact that he only won two but lost nine games during the season. In what would be Jim Lemon's last year as manager, the Senators came in last place in the American League, winning 65 games while losing 96. Bosman would fare better a year later when he went 14 and 5 with a stellar .219 earned run average. (FC Associates.)

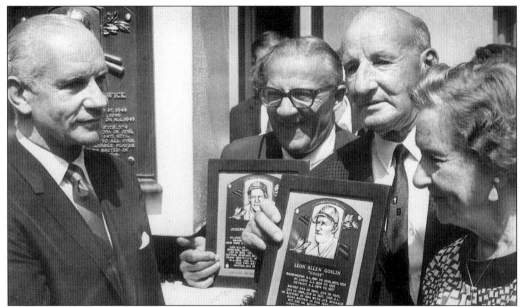

SENATORS GREAT GOOSE GOSLIN, HALL OF FAME, 1968. Even though the 1968 season for the Senators was dreadful, old-time Washington fans celebrated once again when slugger Goose Goslin, Senators star during the 1924, 1925, and 1933 World Series, was inducted into the Baseball Hall of Fame. Pictured here is Gen. William D. Eckert, acting commissioner of baseball, as he presents plaques to inductees Joe Medwick, Goose Goslin, and Mrs. Kiki Cuyler representing her deceased husband. (B. Loughman.)

THE CLOWN PRINCE OF BASEBALL, C. 1968. Although no longer officially associated with the Senators, Al Schacht was still entertaining major league fans in 1968, nearly 50 years after his first appearance as a Washington Senators pitcher. (B. Loughman.)

EXCITEMENT AGAIN! That Senators owner Robert Short would coax Ted Williams out of retirement after nine leisurely years fishing at his home in Florida would be the biggest story in baseball at the end of the 1968 season. Ted knew hitting, agreed to manage the Senators, and smartly surrounded himself with fine coaches like the former great gloveman and future Hall of Famer Nellie Fox. The result? The team won an astounding 86 games in 1969 and "Teddy Ballgame" was named American League Manager of the Year by the A.P. (T.G.)

"The Capital Punisher," Frank Howard, 1969. From 1965 through 1971, 6-foot-7 slugger "Hondo," a nickname that came from the old John Wayne movie, was a bona fide star for the Washington Senators. His most productive year was under the tutelage of manager Ted Williams. Ted, who knew a thing or two about hitting, helped Howard in 1969 when the big man smacked 175 hits, 48 of them for home runs. He also had 111 runs and RBIs. The next year, Ted's second at the helm, Howard would again be spectacular when he pounded 44 homers and hit a solid .283. (FC Associates.)

A 1970 WASHINGTON SENATORS PROGRAM. On opening day 1970 expectations were high in the capital city after the Senators improved dramatically during Ted Williams's first year as manager. This scorecard features the team's "Number One" fan, President Richard Nixon, along with manager Ted Williams, "Hondo," and owner Robert Short. Unfortunately, the season ended badly for the team when they came in last place in the American League over 30 games behind their neighbor, the first-place Baltimore Orioles. (FC Associates.)

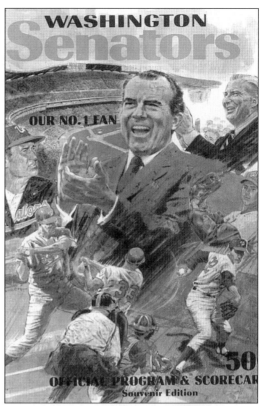

DAVID EISENHOWER, 1970. Tending to his duties as Chief Executive, President Nixon was not able to throw out the first ball to inaugurate the 1971 season. That duty was bestowed upon baseball buff David Eisenhower, President Nixon's son-in-law and President Eisenhower's grandson. A month after the opening game, young Eisenhower volunteered to do "odd jobs" as the Senators' statistician while he was attending law school. (B. Loughman.)

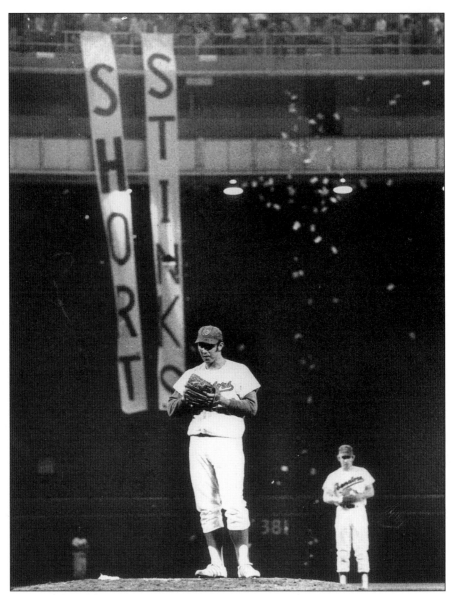

MAJOR LEAGUE BASEBALL LEAVES WASHINGTON, 1971. The year 1971 and the name Robert Short will live in infamy for Washington baseball fans forever. After manager Ted Williams could not improve the team who lost 96 games for the year and fan support continued to dwindle, Short put the team up for sale. There were no takers and major league owners granted Short's wish to move the team to Texas. Washington's last home game, on September 30, 1971, was an eerie and disturbing end to the great professional baseball tradition in the nation's capital. This photo showing Dick Bosman preparing to throw the game's first pitch, perfectly captures all of Washington's displeasure at owner Short's decision. Frank Howard fittingly hit the Senators' last home run in the sixth inning igniting a rally against the dreaded New York Yankees. However, the game was forfeited in the ninth inning, with two outs and the Senators ahead, 7 to 5. The fans stormed the playing field and professional baseball ended after over 120 years in the city. Thirty years later, Washington, D.C. is still without a professional baseball team. (B. Loughman.)

106

Seven

STATESMEN AS SPORTSMEN

President Taft is well known for originating the tradition of the president throwing out the first ball to open each year's major league baseball season. Though the "presidential first pitch" is now cemented as an American ritual of spring, what is less well-known is that presidents have long enjoyed playing ball with their contemporaries. In fact, in 1778 at Valley Forge, a Revolutionary War soldier under the command of General George Washington wrote in his journal perhaps the earliest-known reference to the game of baseball. The soldier dutifully reported that the troops played what would be later called "base ball" and that the General himself actually enjoyed playing ball with his aides.

Who were some of the outstanding ballplayers who became president? Even as schoolchildren we learned that Abraham Lincoln, an imposing man at 6 feet 4 inches, was known to be a great wrestler and pounded railroad stakes for exercise. He also enjoyed playing baseball while practicing law in Springfield, Illinois and, as president, reportedly enjoyed watching ball games at the "White Lot," a field next to the White House that was frequently used for playing the National Pastime.

President Andrew Johnson and almost all succeeding presidents in the 19th century were also avid fans of the game. In fact, Johnson himself is said to have hosted a dinner for the Washington Nationals Baseball Club after they returned from their tour of the west in 1867. President James Buchanan was the first president to attend a major league game when he cheered on the Nationals at the old Swampoodle Grounds in 1892.

The list goes on and on. Young Dwight Eisenhower, while attending high school in Abilene, Kansas, played the game with skill and finesse. We know that Ike absolutely loved the game, and it has been reported that he even played semi-professional baseball in Kansas during the summer when he was home from West Point. President Eisenhower's two-time vice president and later chief executive himself, Richard Nixon, was a true fan who was able to rattle off baseball statistics with the best of them. President Nixon's successor, Gerald Ford, was also a fine baseball player who "starred" in many a game during the Congressional baseball contest. That annual event, the Congressional Game in which Republicans take on Democrats on the baseball diamond, is played in the Capital City even today.

Bill Mead and Paul Dickson, in their classic book Baseball: The President's Game *called President Bush "the natural." There is no question that Bush Senior was the best ballplayer who thereafter became president in our history. Directly after World War II, Bush entered Yale, played first base for the varsity team and captained the Yale ball club to two-championship series in 1947 and 1948. Like his idol Lou Gehrig, Bush played in every game for his entire collegiate career. The tradition continues, of course, as we all know that President George W. Bush loved to play the game, once owned part of the Texas Rangers (whose roots are . . . the Washington Senators expansion team), and even regularly invites city youngsters to play tee-ball on the White House lawn.*

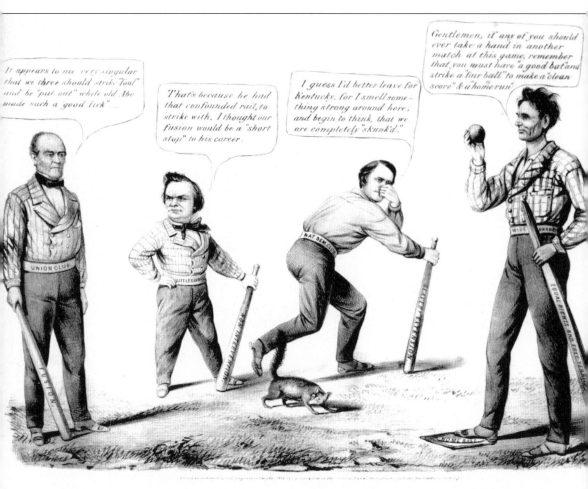

THE NATIONAL GAME. THREE "OUTS" AND ONE "RUN".
ABRAHAM WINNING THE BALL.

THE NATIONAL GAME. THREE OUTS AND ONE RUN, 1860. This early Currier and Ives lithograph shows sportsman Abraham Lincoln with his political rivals for the presidency. From left to right are John Bell, John Breckinridge, and Stephen Douglas. Lincoln was known to enjoy watching and playing baseball from his early years in Illinois through his presidential tenure. In fact, a legend, probably false, persists that Abe was even playing ball when he received word that he won the Republican presidential nomination. (The Lincoln Museum.)

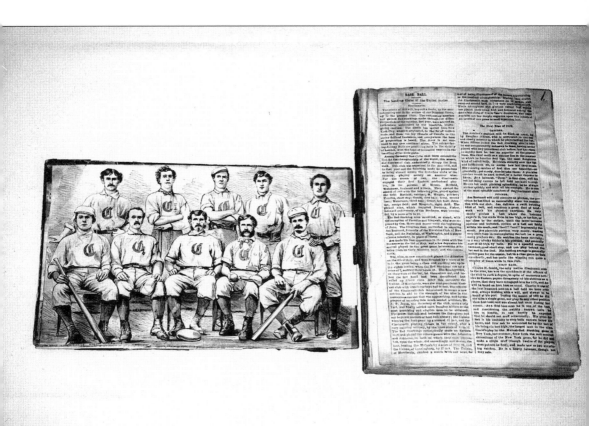

THE 1869 RUTHERFORD HAYES FAMILY SCRAPBOOK. Even before becoming president in 1877, Rutherford B. Hayes, as governor of Ohio, and his family enjoyed the game of baseball and followed the exploits of their favorite home-state team. This photo shows Hayes's own scrapbook of game-by-game newspaper clippings that the family compiled to document the famous national tour of baseball's first all-professional team, the Cincinnati Red Stockings. The scrapbook also features a *Harper's Weekly* illustration of the team which included George Wright, formerly of the Washington Nationals. Incredibly, the Red Stockings won 90 consecutive games over a two year period. (Rutherford B. Hayes Presidential Center.)

RUTHERFORD HAYES BASEBALL LETTER TO SON BIRCHARD, 1870.

I see by the Journal you are playing base ball, and that you play well. I am pleased with this. I like to have my boys enjoy and practice all athletic sports and games, especially riding, rowing, hunting and ball playing. But I am a little afraid from Uncle says that over exertion and excitement in playing base ball will injure your hearing. Now you are old enough to judge of this and regulate your conduct accordingly. . .
—R.B. Hayes

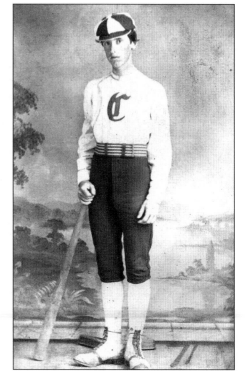

BIRCHARD A. HAYES CdV IMAGE, 1871. This rare Carte-de-Visite photoprint shows President Hayes's oldest son and baseball enthusiast, Birchard, in full baseball regalia. President Hayes encouraged the young man's ball playing.

PRESIDENTIAL BOOST.
Amateur baseball in the city got a major boost in 1904 when President Teddy Roosevelt , a longtime advocate of the great outdoors, decreed that the "White Lot," next to the White House, be opened up to city residents for amateur baseball. Soon, amid great fanfare, three baseball diamonds were laid out, five leagues were formed and the venerable Spalding's produced a special yearbook celebrating the same.

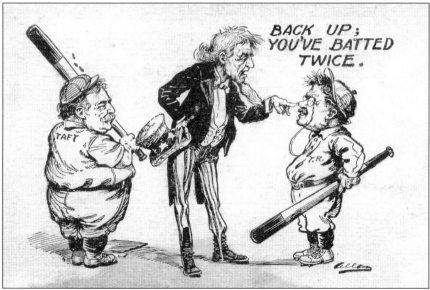

TAFT-ROOSEVELT POSTCARD, 1912. This political postcard features President Taft facing prior President Theodore Roosevelt. Although Taft was a true baseball fan, President Roosevelt preferred horseback riding and hunting to the National Pastime. However, President Roosevelt was credited with directing government officials to open up the Washington Mall for people to be able to play and enjoy the game of baseball. (FC Associates.)

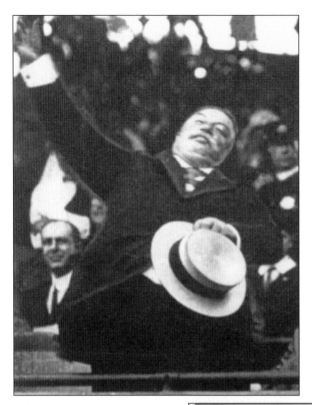

A Tradition Begins. Even though presidents such as Andrew Johnson, Ulysses S. Grant, and James Buchanan enjoyed watching the Washington Nationals play during the 19th century, baseball fan President Howard Taft began the tradition of throwing out the ceremonial first pitch of the major league baseball season. (T.G.)

President Woodrow Wilson, 1917 World Series. President Woodrow Wilson was the first president to attend a World Series Game when he did so in 1915. Two years later, his image would adorn the cover of the 1917 World Series Official Program, a contest between the New York Giants and the Chicago White Sox. Wilson loved to watch Senators games at the ballpark for relaxation during World War I. (FC Associates.)

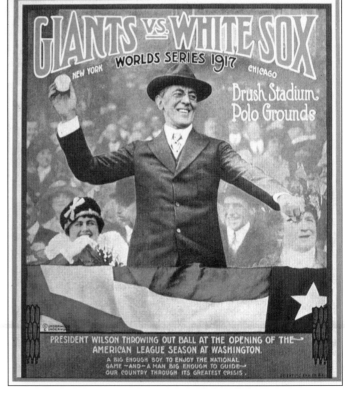

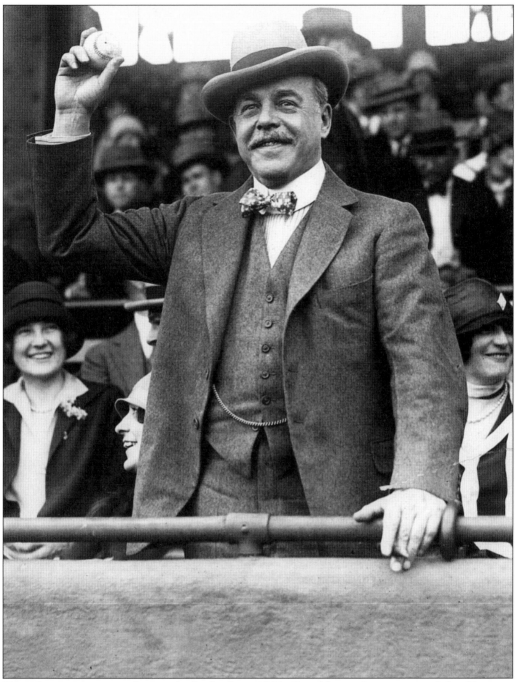

THE CONGRESSIONAL GAME. As far back as 1909, Republican Congressman John Tener, a former major league pitcher with the Chicago Colts and later commissioner of the National League, organized the first Congressional Game. That game, which pits the Republicans against the Democrats, continues to be played annually to this day. Here baseball fan and Speaker of the House Nick Longworth enjoys throwing out the first pitch to start the 1926 Congressional Game. The Democrats won 12 to 9. (B. Loughman.)

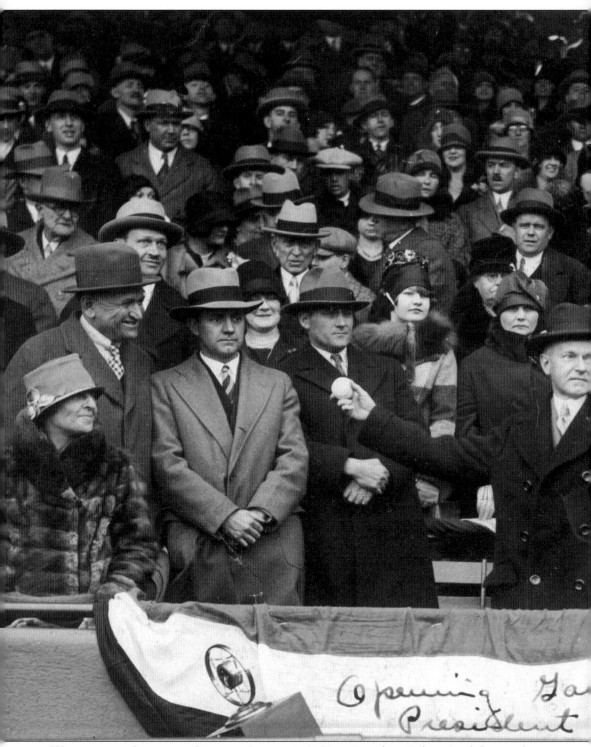

WASHINGTON SENATORS OPENING GAME, 1927. Even President Calvin Coolidge, not known for his great love of athletics, continued with the tradition of throwing out the first pitch to

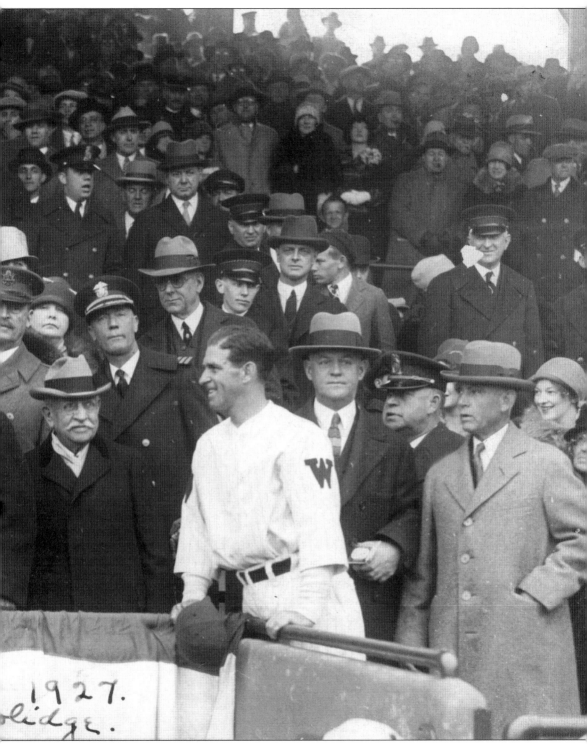

1927.
...lidge.

inaugurate the beginning of the major league baseball season. (T.G.)

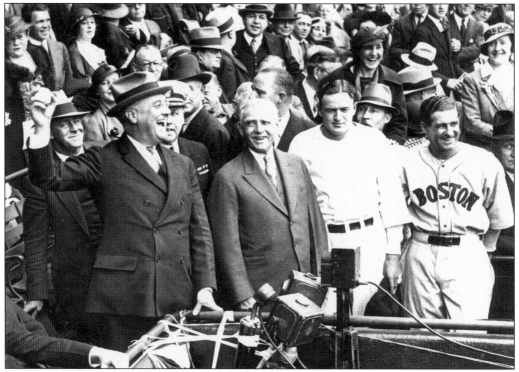

PRESIDENT FRANKLIN D. ROOSEVELT, 1934. Both President Roosevelt and his wife Eleanor were great fans of baseball and enjoyed going to the park and listening to ball games on the radio while at the White House. Here President Roosevelt throws out the first baseball of the 1934 season while a smiling Washington Senators team owner Clark Griffith looks on. (T.G.)

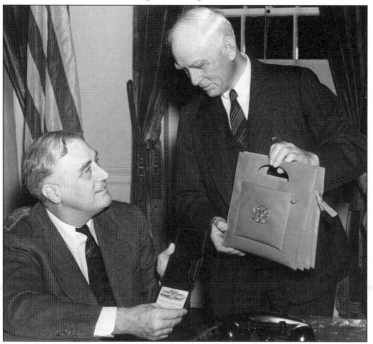

CLARK GRIFFITH AND PRESIDENT ROOSEVELT. This picture shows Washington Senators team owner Clark Griffith performing a duty that he dearly loved. Here Griffith is presenting a season's pass to his friend, President Roosevelt, and showing him a leather purse that would be given to Mrs. Roosevelt. (T.G.)

THE 1933 CONGRESSIONAL BASEBALL GAME WITH GENE TUNNEY AND AL JOLSON. Here Gene Tunney, former heavyweight boxing champion, and Al Jolson, famous stage comedian and singer, are about to share the duty of throwing out the first pitch for the 1933 Congressional Game. The Republicans were to squeak by the Democrats, 18 to 16. Pictured from left to right are American League Umpire Kolls, Gene Tunney, and Al Jolson. (B. Loughman.)

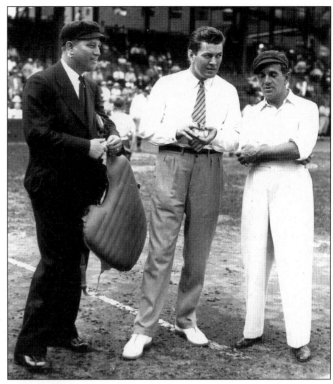

THE 1941 "STATESMEN" WORLD WAR II CHARITY GAME. Representative Hamilton Fish, Republican from New York and manager of the "Statesmen" Congressional team, practices his batting stroke for their upcoming contest against radio announcer Lowell Thomas and his "Nine Old Men" for a wartime charity softball game to be held at Griffith Stadium. Their ballpark was only a few miles from their "practice field" in front of the United States Capitol. (B. Loughman.)

CONGRESSIONAL BALLPLAYERS, 1941. These ballplayers are members of the "Statesmen" Congressional baseball team. Pictured, from left to right, are (kneeling) Rep. James Shanley, batboy J. Fishbait, and Rep. Leo Allen; (standing) Rep. John Sparkman, Rep. C.W. Bishop, Rep. Hamilton Fish, Sen. James Mead, Rep. Gordon Canfield, and Rep. William Stratton. (B. Loughman.)

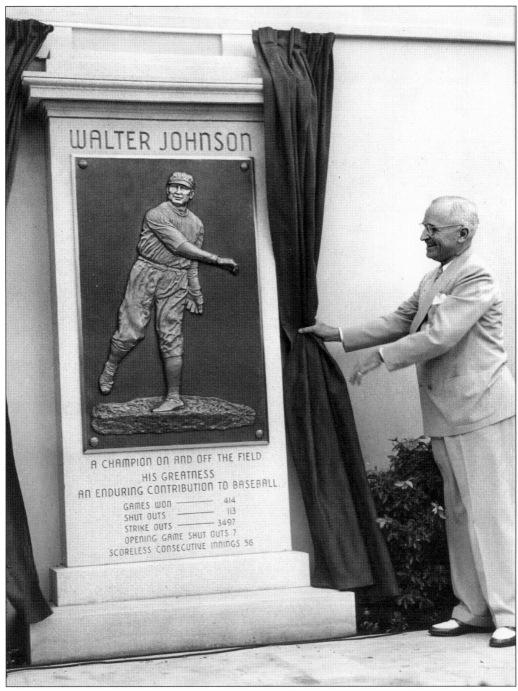

President Truman Commemorating Walter Johnson at Griffith Stadium. This photo shows President Harry Truman unveiling a monument commemorating his friend, the late Walter Johnson, at Griffith Stadium in Washington, D.C. After the stadium was destroyed in 1962, the monument was delivered to Walter Johnson High School in Montgomery County, Maryland, where it still stands. (B. Loughman.)

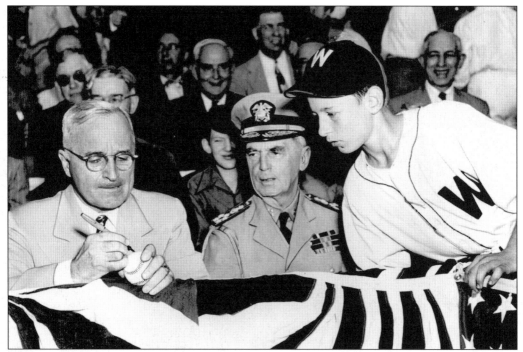

PRESIDENT TRUMAN, 1945. President Harry Truman enjoyed going to the ballpark to see the Washington Senators play. Here the President is signing a baseball for Senators batboy Bobbie Shellon. (Martin Luther King Library Collection.)

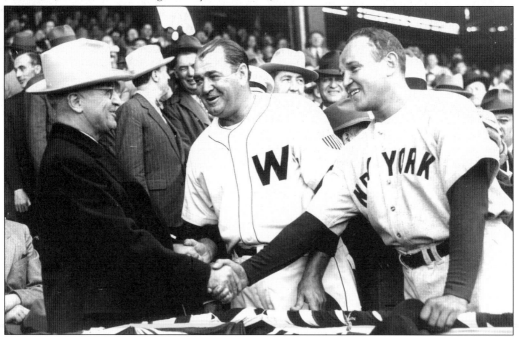

PRESIDENT TRUMAN, OPENING DAY 1947. President Truman greets longtime Washington Senator Bobo Newsome and Allie Reynolds of the New York Yankees on opening day 1947. (Martin Luther King Library Collection.)

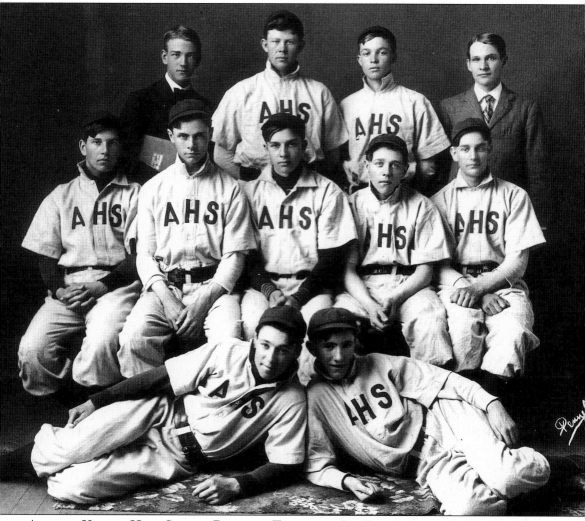

ABILENE, KANSAS HIGH SCHOOL BASEBALL TEAM WITH IKE EISENHOWER, 1908. This photo shows young Ike Eisenhower (back row third from left) posing with his high school baseball team from Abilene, Kansas, during the 1908 school year. (Dwight D. Eisenhower Library.)

When I was a small boy in Kansas, a friend and I went fishing and as we sat there in the warmth of the summer afternoon on the riverbank, we talked about what we wanted to do when we grew up. I told him that I wanted to be a major league baseball player, a genuine professional like Honus Wagner. My friend said that he'd like to be President of the United States. Neither of us got our wish.

—Dwight D. Eisenhower

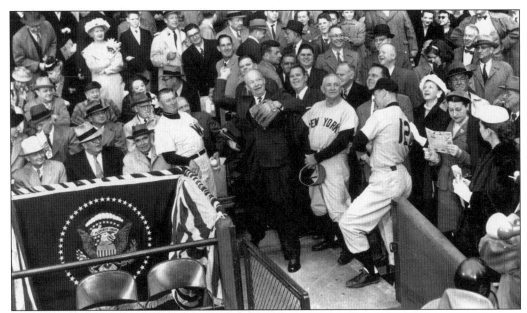

PRESIDENT DWIGHT D. EISENHOWER, OPENING DAY 1956. President Eisenhower is known for playing golf during the 1950s, but he was a rabid baseball fan as well. Here he tosses out the first ball to inaugurate the 1956 baseball season in which the Senators would take on the American League Champion New York Yankees. (T.G.)

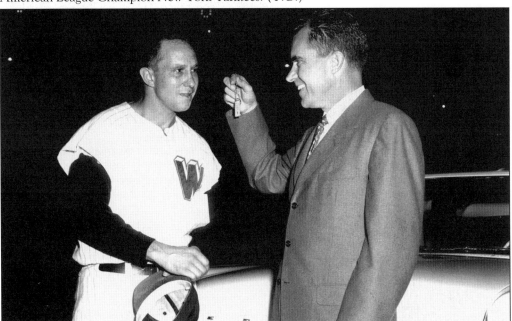

VICE PRESIDENT NIXON WITH ROY SIEVERS, 1957. Vice President Richard Nixon, who would become president in 1968, was probably the biggest presidential baseball fan of all. He thoroughly enjoyed pouring over baseball statistics and loved to banter with ballplayers during his long years of residence in Washington, D.C. Here he presents the keys to a new car to Washington Senators slugger Roy Sievers who led the American League with 42 home runs in 1957. (Martin Luther King Library Collection.)

PRESIDENT KENNEDY, OPENING DAY 1961. President John F. Kennedy visited Griffith Stadium as much as he could during his tenure as President of the United States. Here President Kennedy commemorates the opening of the 1961 baseball season. (B. Loughman.)

YOUTHFUL LYNDON BAINES JOHNSON. President Johnson is known more for his love of politics than sports, but even as a youth he enjoyed playing baseball. Here young Lyndon is catching for his team in Texas long before he entered the political arena. (Lyndon Baines Johnson Library.)

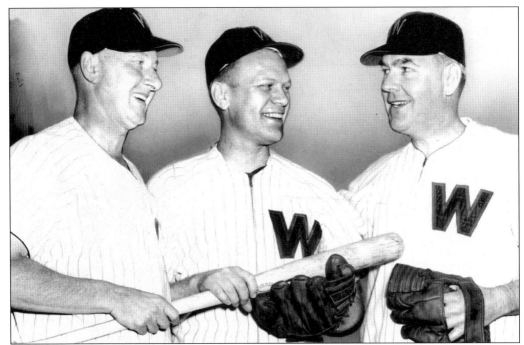

REP. GERALD FORD CONGRESSIONAL BASEBALL GAME, 1956. Gerald Ford spent over three decades in Washington, D.C., first as a congressman and later as President of the United States. Here Representative Ford joins fellow congressmen prior to the 1956 Congressional Baseball Game at Griffith Stadium in Washington, D.C. (Gerald R. Ford Museum.)

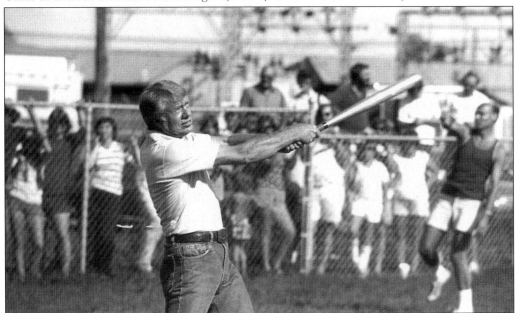

PRESIDENT CARTER SWINGING AWAY, 1976. When President Jimmy Carter came to the nation's capital from Plains, Georgia, he brought with him his love of playing softball for exercise. Here the President has just connected during a softball game in Georgia the year of his election. (Jimmy Carter Library.)

WHO SPORTSCASTER DUTCH REAGAN, C. 1935. As a young man, Ronald Reagan broadcast the Chicago Cubs baseball games over station WHO beaming from Des Moines, Iowa. Years later as president, he delighted in telling reporters how he "covered the game" from a telegraphic report in which an operator would hand him brief comments about an ongoing game and he "recreated" the baseball action by inserting details of his own. This was a common practice in radio during the 1930s. (*The Sporting News.*)

"THE WINNING TEAM," 1952. Because he was such a baseball fan, President Reagan often recalled how much he enjoyed portraying baseball great Grover Cleveland Alexander in the 1952 Warner Brothers movie *The Winning Team*. This lobby card shows Reagan as Alexander, surrounded by teammates from the Chicago Cubs. (FC Associates.)

DORIS DAY · RONALD REAGAN *in...* and as *"The Winning Team"* FRANK LOVEJOY PRESENTED BY WARNER BROS.

YALE TEAM CAPTAIN GEORGE BUSH, 1948. President George H. Bush was undoubtedly the best baseball player to serve in the White House. He was said to be an outstanding first baseman and would keep his cherished mitt in his desk drawer in the Oval Office. In 1947 and 1948, Bush captained his Yale baseball team in the finals of the College World Series. (George Bush Presidential Library and Museum.)

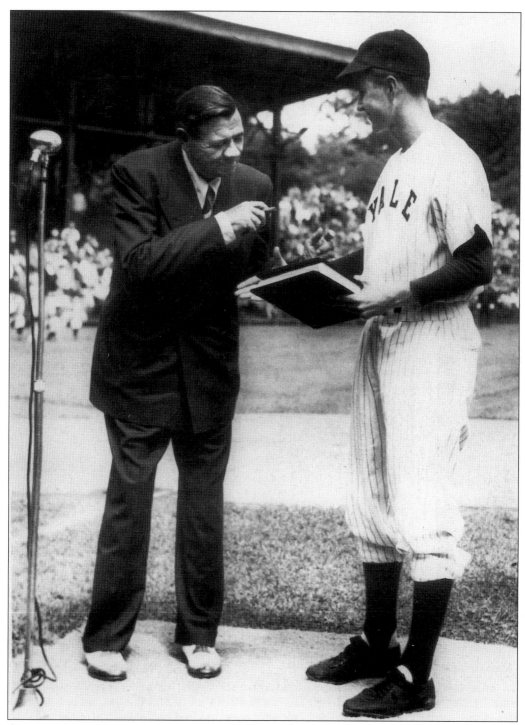

CAPTAIN BUSH MEETS BABE RUTH, 1948. Shortly before his death, a frail Babe Ruth traveled to New Haven, Connecticut, to present the Yale Library with the manuscript copy of his book. Here Capt. George Bush, representing the Yale team, accepts the manuscript from the Bambino. (George Bush Presidential Library and Museum.)

South Lawn Slugger Receiving Presidential Memento, 2001. Beginning in his first year in office, longtime baseball fan and prior major league team owner, President George W. Bush, invited Washington, D.C. schoolchildren to play tee ball on the South Lawn of the White House. Here Quintin Thomas Jr. of the Satchel Paige Little League receives a special commemorative baseball from President Bush. (The White House.)

President George W. Bush, White House South Lawn Tee Ball, 2001. In an effort to spur interest in baseball and help promote the national pastime, President Bush began hosting a series of tee ball games on the South Lawn. Here, at the inaugural game, an appreciative Keith Jones, president of the Satchel Paige Little League, presents the president with a special baseball bat. (The White House.)